The Pencil Box

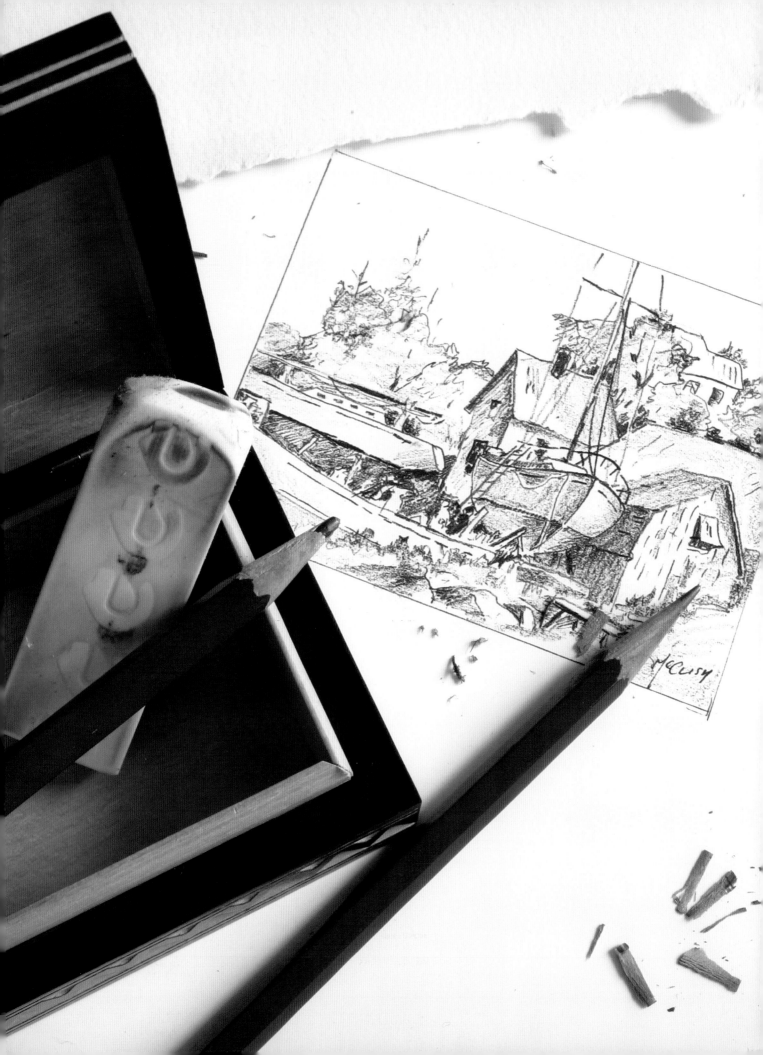

The Pencil Box

A Treasury of Time-Tested
Drawing Techniques and Advice

From the editors of *The Artist's Magazine*
and North Light Books

NORTH LIGHT BOOKS
CINCINNATI, OHIO
www.artistsnetwork.com

Other fine North Light Books are available from your local bookstore, art supply store or direct from the publisher.

10 09 08 07 06 5 4 3 2 1

DISTRIBUTED IN CANADA BY FRASER DIRECT
100 Armstrong Avenue
Georgetown, ON, Canada L7G 5S4
Tel: (905) 877-4411

fw

F+W PUBLICATIONS, INC.

DISTRIBUTED IN THE U.K. AND EUROPE BY DAVID & CHARLES
Brunel House, Newton Abbot, Devon, TQ12 4PU, England
Tel: (+44) 1626 323200, Fax: (+44) 1626 323319
Email: mail@davidandcharles.co.uk

DISTRIBUTED IN AUSTRALIA BY CAPRICORN LINK
P.O. Box 704, South Windsor NSW, 2756 Australia
Tel: (02) 4577-3555

Library of Congress Cataloging in Publication Data
The pencil box : a treasury of time-tested drawing techniques and advice / from the editors of The Artist's Magazine and North Light Books.
 p. cm.
 Includes index.
 ISBN-13: 978-1-58180-729-5 (alk. paper)
 ISBN-10: 1-58180-729-5 (alk. paper)
 1. Pencil drawing--Technique. 2. Colored pencil drawing--Technique. I. North Light Books (Firm) II. Artist's magazine (Cincinnati, Ohio)
 NC890.P385 2006
 741.2'4--dc22
 2005054702

Edited by Erin Nevius
Designed by Guy Kelly
Production art by Jessica Schultz
Production coordinated by Mark Griffin

METRIC CONVERSION CHART

To convert	to	multiply by
Inches	Centimeters	2.54
Centimeters	Inches	0.4
Feet	Centimeters	30.5
Centimeters	Feet	0.03
Yards	Meters	0.9
Meters	Yards	1.1
Pounds	Kilograms	0.45
Kilograms	Pounds	2.2

CONTRIBUTORS

JOHN BICKFORD

A graduate of Exeter and MIT, Bickford paints landscapes, portraits and still lifes in oil and acrylics. He attended classes at Yale and the Vesper George Art Schools and has also studied with Charles Sovek, Ann Templeton, Louise Bourne, Frank Frederico, William Vrsak and others. He is a member of The New Haven Paint and Clay Club, the American Artists Association, the Lyme Art Association and several local art groups in Connecticut and Maine. His work can be seen in the Fore Street Gallery in Portland and the Bayview Gallery in Camden, both in Maine, as well as on his Web site: www.johnbickford-art.com. He has been a contributing editor to *The Artist's Magazine* for many years.

JANIE GILDOW

Gildow is an internationally known colored pencil artist and author. As a professional artist, she has won both national and international awards. Her work appears in many publications. She is the author of *Colored Pencil Explorations* (North Light Books, 2003) and co-author of *The Colored Pencil Solution Book* (North Light Books, 2000). Gildow teaches workshops throughout the United States and is featured in two colored pencil DVDs currently available from Creative Catalyst Productions: *The Colored Pencil, Getting Started Right* and *The Art of Colored Pencil, The Light Touch*. Janie lives in Arizona with her husband and two cats, Murfee and Wilson.

CATHY JOHNSON

Cathy Johnson is a contributing editor to *The Artist's Magazine* and author of several books, including *Watercolor Pencil Magic* (North Light Books, 2002) and *First Steps: Sketching and Drawing* (North Light Books, 1995).

ANDRE KOHN

Trained in Russia, artist and instructor Andre Kohn lives in Scottsdale, Arizona.

BUTCH KRIEGER

Krieger was born in Oakland, California, in 1945, and grew up mostly in Los Angeles. He received an M.A. in Political Science from the University of California at Riverside, and later an M.A. in art history from Brigham Young University. He was a courtroom illustrator for eighteen years with clients including KIRO-TV, KOMO-TV, KING-TV, as well as CBS, CNN, the Associated Press, United Press International, *PM* Magazine and *USA Today*. He is now a fine art portrait and figure painter, and a writer for *The Artist's Magazine, Watercolor Magic, The Pastel Journal, The Portrait Signature* (the quarterly journal of the American Society of Portrait Artists) and North Light Books. He is the author of *Watercolor Basics: People* (North Light Books, 2001).

ANN KULLBERG

Ann Kullberg is a self-taught artist who has been working in colored pencil since 1987. She is a commissioned children's portrait artist, gives numerous workshops around the country, serves as a juror for national art competitions and produces a line of colored pencil art instruction kits. She is the author of *Capturing Soft Realism in Colored Pencil* (North Light Books, 2002) and *Colored Pencil Portraits Step by Step* (North Light Books, 1999). Her work can be viewed online at www.annkullberg.com.

PAUL LEVEILLE

Paul Leveille paints portraits of internationally distinguished clients. He is a graduate of the Vesper George School of Art in Boston, Massachusetts, and spent twelve years as an art director and illustrator in advertising. He is a member of many art associations, including The Portrait Society of America.

BART LINDSTROM

Bart Lindstrom has lectured and demonstrated with Daniel E. Greene and Nelson Shanks at the Portrait Arts Festival of the American Society of Portrait Artists. He's taught at the Art Students League in New York City and graduate art at the University of Texas. He lives with his wife and children in Tennessee.

STANLEY MALTZMAN

Stanley Maltzman is a naturalist artist and instructor living in the Hudson River Valley in New York.

JERRY McCLISH

McClish is a loose watercolor artist who has conducted many art workshops in the U. S. and Europe. He has had sketching and watercolor programs on educational TV and a fifteen-week sketching program on PBS sponsored by Strathmore Papers. McClish was president of the International Society of Marine Painters for thirteen years.

ROCCO J. MIRRO

Mirro is a self-taught graphic designer, illustrator and pencil portrait artist. His portraits have won many awards, from Honorable Mention and First Place to Best in Show. His work has been featured in *The Artist's Magazine, Artist's Sketchbook, RSVP* (The Directory of Illustration and Design), *International Artist's Magazine* and *Canine Images*. Mirro has a number of portraits on display on both the Queens and Staten Island campuses of St. John's University, New York. He is currently part of the creative design team at St. John's University and resides in Malverne, N.Y., with his dog Gemini.

BARBARA BENEDETTI NEWTON

Newton attended art school in Seattle, Washington, and began her art career in 1966 as a fashion illustrator. Her work and writing has appeared in numerous art magazines and books, including all volumes of *The Best of Colored Pencil* (from the Colored Pencil Society of America). She is co-author of *The Colored Pencil Solution Book* (North Light Books, 2000). She instructs colored pencil and pastel workshops at Frye Art Museum, Seattle, and Sitka Center for Art & Ecology, Oregon. Newton is a charter member, signature member and past president of the Colored Pencil Society of America. She is also a member of Northwest Pastel Society and Northwest Watercolor Society and serves on the board of Women Painters of Washington. Barbara is represented by galleries in Washington and Oregon. Her work can be viewed at her Web site: www.barbaranewton.com.

CARRIE STUART PARKS

Parks has spent many years developing composite drawings of suspects in major national and international cases for the FBI, as well as creating exquisite watercolors and stone carvings. She travels with her husband Rick Parks, also an artist, across the United States and internationally to teach one-week composite drawing courses to a variety of participants, from large law-enforcement agencies to small, two-person police departments, from Secret Service and FBI agents to interested civilians. Carrie has won numerous awards for her innovative teaching methods and general career excellence and is a signature member of the Idaho Watercolor Society. She is the author and illustrator of *Secrets to Drawing Realistic Faces* (North Light Books, 2003) and co-author with her husband of *Secrets to Realistic Drawing* (North Light Books, 2005). Carrie and Rick reside in North Idaho and may be contacted through their Web site at www.stuartparks.com or by e-mail at carrie@stuartparks.com.

DAVID RANKIN

David Rankin is a graduate of the Cleveland Institute of Art and an award-winning professional watercolor painter. His work has been featured in museum exhibitions in Japan, Sweden, Canada and across the United States. His painting has appeared in numerous books and magazines, and he is the author of *Fast Sketching Techniques* (North Light Books, 2000). His main emphasis is India, but Rankin also paints the Southwest United States, Florida, the Great Lakes region and his hometown of Cleveland, Ohio.

BILL TILTON

Bill Tilton is a contributing editor to *The Artist's Magazine* and creator of their column "The Drawing Board." He resides in Raleigh, North Carolina.

TABLE OF CONTENTS

Contributors
Page 4–5

1 Materials and Techniques:
A Primer of Basics
Page 8

Experiment With Drawing Media
Combine Drawing Techniques for an Intricate Picture
The Importance of Light and Shadow
Explore Shading Tools
Demonstration: Shading with Stumps, Pencils and Graphite
Create Tones By Smudging
Use an Eraser for Brighter Drawings
Tips for Daily Sketching
Create a Complete Sketch
Draw Your Memories Realistically
Use a Scale to Control Values
Adjust Your Values
Illuminate Your Scenes With Light
Light From Sketch to Drawing
Master the Subtleties of Shadow
Use Shadows to Make Realistic Light
Demonstration: Drawing With Negative Values
Add Energy with Accents
Define Your Edges for Realism
Tools for Drawing From Photographs
Check for Accuracy
Divide Space in Your Painting

2 Landscapes:
The World Around Us
Page 56

Establish a Strong Picture Frame
Give Your Scenes a World of Depth
Use Perspective to Create Realism
Add Variety to Your Trees
Demonstration: Use Value and Light to Create Forests
Use Roads to Add Realism
Add Realistic Rocks to Your Landscapes

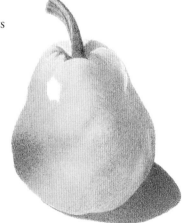

3 Portraits and Figures:
Your Friends and Neighbors

Page 72

Capture Realistic Eyes
Demonstration: Drawing Eyes
Draw the Many Shapes of Ears
Draw Realistic Hair
Demonstration: Separating the Values to Create Hair
Drawing a Self-Portrait
Portraits of the Elderly
Master the Figure
Demonstration: Tighten Your Focus
Start With Basic Shapes and Gestures
Demonstration: Constructing a Figure
Drawing Convincing Figures
Add Personality to Your Drawings
Demonstration: Creating Lifelike Drawings From Photos
Draw Expressive Hands
Match Clothing to the Form Beneath

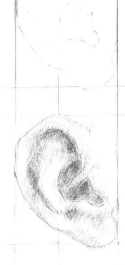

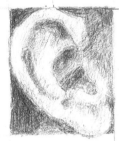

4 Colored Pencil & Mixed Media:
Color Your World

Page 102

Explore Colored Pencils
Experiment With Paper
Even Colored Pencil Application
Pressure and Value Changes
Color Mixing
Smooth Colored Pencil Applications
Demonstration: Finding Exquisite Color Combinations
Demonstration: Capturing Reflections With Colored Pencils
Establish Value With Colored Pencils
Define Volume With Pastels
Demonstration: Combining Mediums to Create Excitement
Demonstration: Underpainting With Watercolor
Using Ink With Colored Pencils
Demonstration: Establishing an Ink Foundation for Color

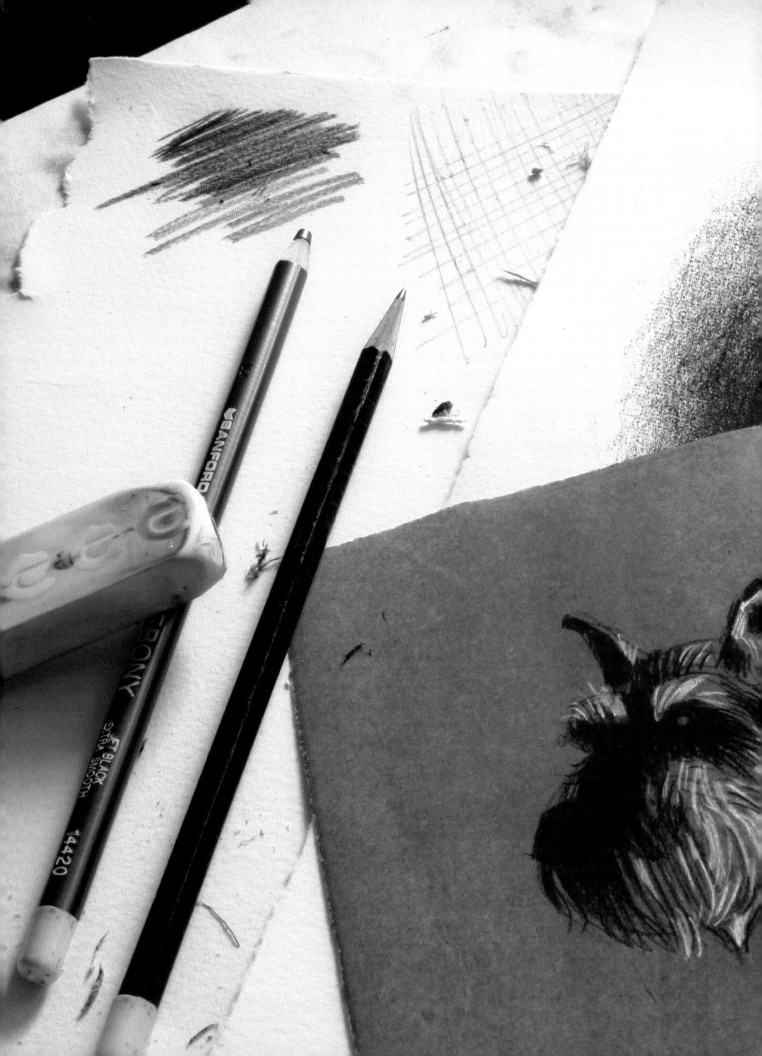

Materials and Techniques:
A Primer of Basics

What would a painter be without his brushes, a sculptor his chisel, a calligrapher his pen? It's crucial that you find the drawing tools that best suit you, as well as stand the test of time. Though it may seem the opposite, there are many different mediums to experiment with in your drawings. Try them all to discover what's possible in this most fundamental art skill.

Likewise, there are many basic techniques artists must master to realistically render their subjects. No matter how much or how little experience you might have, the rudimentary principles of drawing are what will determine the quality of your artwork. Whether you are exploring these techniques or revisiting them, mastering them all will bring your art to a new level.

EXPERIMENT WITH DRAWING MEDIA

Cathy Johnson

Quick and sketchy, calligraphic, roughly shaded or almost photographic—no matter what style you prefer, drawing is one of the most immediate, exciting and satisfying forms of art. To get the most out of the time you invest in drawing, it's a good idea to experiment with the various drawing media to find out which work best for you. Some of us are comfortable with the simplicity of pencils; others prefer the clean, bold linear effects possible with pen and ink. Some of us love the blending possible with charcoal; others can't live without color.

Developing an understanding of the various media and what you prefer can help you capture what you want on paper with maximum enjoyment. With that in mind, let's explore some of the common drawing media and see the effects possible with each.

Pencils

Graphite pencils are the most basic and easily accessible drawing tool. But this category covers lots of ground—from the common No. 2 pencil to mechanical pencils. You can find pencils in varying degrees of hardness. The 6B pencil is thesoftest, the HB falls in the middle and the 4B is the hardest. Hard pencils are very good for detailed drawings. They smear very little, but they don't produce truly dark darks. Pencils in the B range are soft and buttery and capable of tremendous darks, but they smear easily.

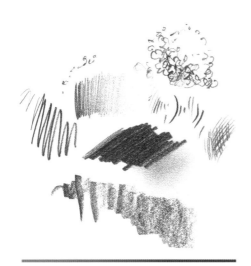

GRAPHITE PENCILS
Roughly the equivalent of the basic No. 2 pencil, an HB pencil is capable of a wide range of values, from light to dark. It will blend somewhat with a fingertip or a paper stump. You can get fine detail with the point or cover broad areas with the side of the lead.

WOODLESS PENCILS
Woodless drawing pencils are pure graphite—they're not encased in wood— and offer lots of expressive possibilities, bold to subtle. You can use the tip for line-work or applying dots, or the side of the pencil to create larger areas of tone.

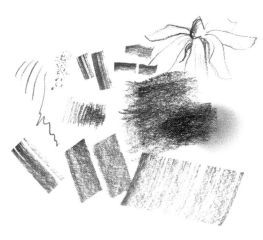

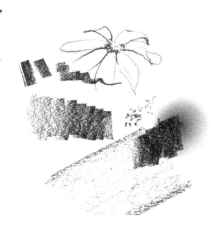

GRAPHITE STICKS

These square or rectangular blocks of graphite are available in several degrees of hardness. You can use the corner of a graphite stick to produce relatively detailed drawings, work with one side of the end for wider lines, or use the entire side of the stick for broad tonal areas. In the example at left, I used the broader-style graphite stick to produce this variety of strokes, dots, squiggles and flat areas. You can then blend the graphite with your fingertip. For the second example (at right), I used a square graphite stick, similar in shape to a hard pastel.

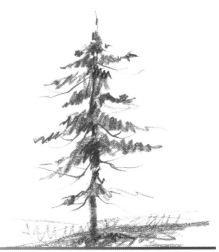

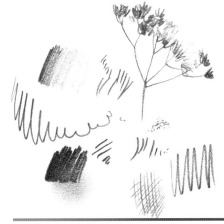

FLAT PENCILS

Artists have been using flat sketching pencils—sometimes called carpenter's pencils—for many years. They are very versatile and offer the capability of quickly covering large areas. In addition to experimenting with the variety of marks this pencil produces, try out a landscape with a single tree as the center of interest.

MECHANICAL PENCILS

Mechanical pencils commonly come equipped with a 0.5mm or 0.7mm lead (the one used for this demonstration has a 0.5mm lead). These pencils never need sharpening—you simply advance the lead. Mechanical pencils are great for linework, but it can be difficult to produce areas of tone with them. Still, unless you're using very hard lead, you should be able to blend the graphite softly, as I did here.

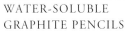

WATER-SOLUBLE GRAPHITE PENCILS

While not capable of the value range offered by some other types of drawing media, water-soluble graphite pencils make nice washy, atmospheric effects when touched with a brush loaded with clear water. This drawing was done with a medium-hard Derwent water-soluble pencil. I drew the hat pin holder, then wet the drawing with clear water and blended the edges with a brush.

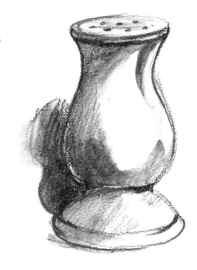

Charcoal

Charcoal may well have been the first drawing tool. Today, artists have a number of exciting choices within the charcoal family. Vine charcoal, made from carbonized willow twigs, comes in a range of thicknesses; charcoal sticks are created by pressing charcoal into round, octagonal or square bars that resemble black pastels. There are also several types of charcoal pencils—charcoal encased in wood or wrapped in paper. These pencils are available with hard, soft or medium-hard charcoal.

Charcoal smears easily, and you can take advantage of this to create interesting tonal areas. But because of this tendency toward smearing, it's a good idea to work from left to right if you're right-handed to keep from dragging your drawing hand through

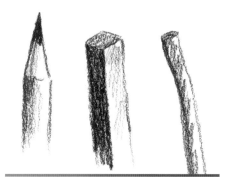

CHARCOAL OPTIONS
A 2B charcoal pencil (left) and a charcoal stick (middle) are harder than vine charcoal (right), and are thus less likely to smear.

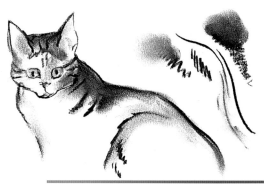

COMBINING TECHNIQUES
When working with charcoal, I like to combine a linear technique with light blending to suggest volume, as I did in the sketch of my cat, Margaret.

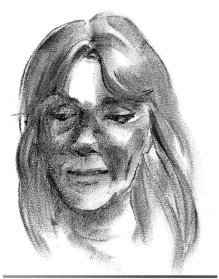

VINE CHARCOAL
Soft, expressive vine charcoal works well for large, bold works or subtle shadings, as in this portrait.

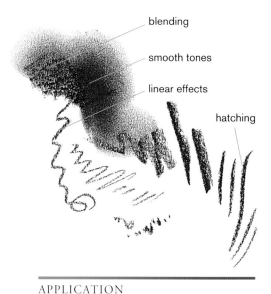

blending

smooth tones

linear effects

hatching

APPLICATION
There are lots of ways to apply charcoal. Here, I used hatching, linear effects and smooth areas of tone, which I then rubbed with my finger to soften one edge.

previously applied charcoal. If you need to go back in and add more to the drawing, try spraying workable fixative over the charcoal.

Pen and Ink

If you like precise, even linework, try using pens. Unlike some of the other drawing tools in this article, you can't use the side of the pen's point to produce larger areas of tone, so you'll have to rely on three techniques: stippling, hatching and crosshatching. Stippling involves creating areas of tone with dots; hatching is the technique of producing areas of tone with parallel lines; and crosshatching uses layers of parallel lines applied at angles to one another to build areas of tone.

FIBER-TIPPED PENS
I like to use inexpensive fiber-tipped pens for quick gesture drawings like this raccoon.

FINE-POINT STRATEGIES
Fine-pointed, fiber-tipped pens work well for creating fine, uniform lines. But you'll need to use stippling, hatching or crosshatching to suggest tone, as I did in this drawing of an Easter lily.

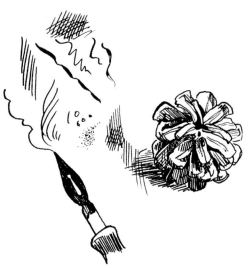

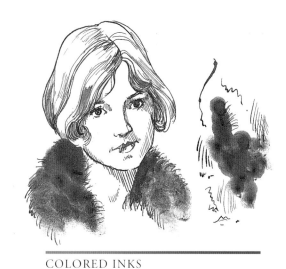

DIP PENS AND INDIA INK
Linework and crosshatching are the traditional techniques associated with a dip pen and India ink. These pens can be fitted with a variety of tips, called nibs. This particular nib is a flexible drawing tip—note the varied lines it can produce.

COLORED INKS
You can give your pen-and-ink works greater energy and excitement by experimenting with colored inks. In this example, I used brown ink to create a nostalgic feeling.

13

COMBINE DRAWING TECHNIQUES FOR AN INTRICATE PICTURE

Paul Leveille

The simple art of drawing is how many of us first expressed our creativity through art. Most of us go on to seek more elaborate creations in other media, but we can't forget that complexity isn't just an attribute of painting. In black-and-white drawings you can create a very intricate picture, and the secret for this is to use a variety of techniques.

By mixing up the ways you apply your medium, you can create a wide array of visual effects, and as a result you'll be able to render a wide range of subject matter. And, more importantly, by varying the effects within a single drawing, you can create elaborate and fascinating compositions with a minimum of materials. Try combining several drawing, blending and erasing strategies in your next drawing with the intent of making a truly complete picture, and perhaps you'll find that less is more.

LIGHT VS. DARK
You can create a variety of light and dark areas by moving your pencil tip back and forth across the paper rapidly while increasing or decreasing pressure.

CROSSHATCHING
Draw a series of lines in one direction, then cross over them with another series of lines to form a grid pattern called crosshatching. The pattern can be crossed many times in various directions to produce different tones.

BLOCKING
By using the side of a piece of compressed charcoal, you can cover large areas quickly and solidly.

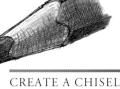

CREATE A CHISELED EDGE
To get a chiseled look, shave the end of your pencil with a utility blade or craft knife. Then shape the tip into a chisel by rubbing it on sandpaper. Additionally, check for varying degrees of hardness and softness in a pencil lead.

BLENDING
Paper stumps or tortillions can also be used for blending.

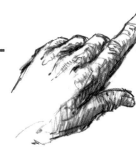

SOFTENING CONTRAST
If you have a dark area up against a light area, you may want to soften the contrast. Rubbing with your finger can create a soft transition.

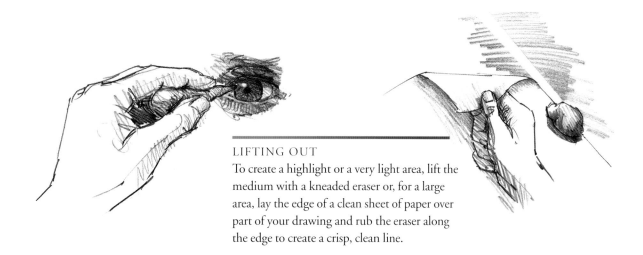

LIFTING OUT

To create a highlight or a very light area, lift the medium with a kneaded eraser or, for a large area, lay the edge of a clean sheet of paper over part of your drawing and rub the eraser along the edge to create a crisp, clean line.

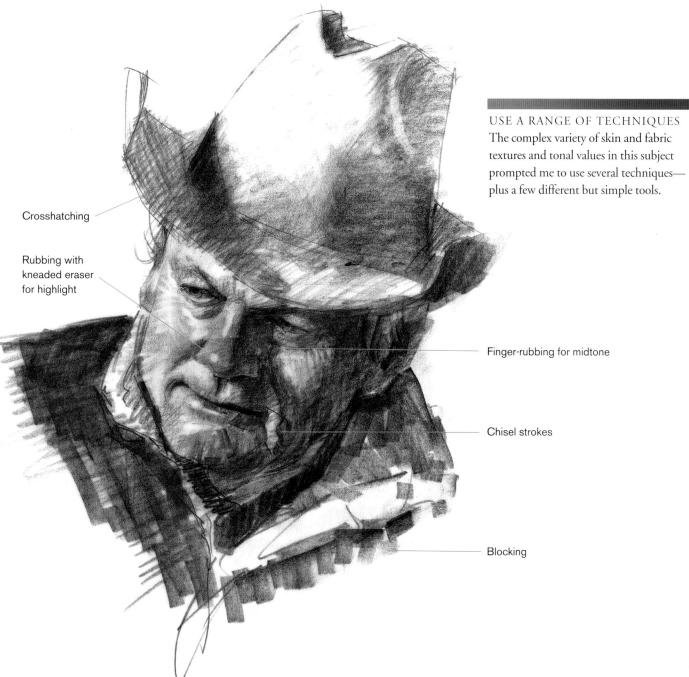

USE A RANGE OF TECHNIQUES

The complex variety of skin and fabric textures and tonal values in this subject prompted me to use several techniques— plus a few different but simple tools.

Crosshatching

Rubbing with kneaded eraser for highlight

Finger-rubbing for midtone

Chisel strokes

Blocking

THE IMPORTANCE OF LIGHT AND SHADOW

*Janie Gildow and
Barbara Benedetti Newton*

Shadows exist because there is light. The differences between light and shadow are what make our world three-dimensional. Shadows help define the form and volume of objects. If everything were the same color and value, what a terrible time we would have, bumbling our way around, continually bumping into things we couldn't see.

Form Shadows

Shadows that appear on an object are called *form shadows*. They define the surface of the object and are usually made up of gradually changing values. They appear only on the object itself. Their value range is directly related to the local color of the object and the power of the light. They may contain reflected color.

Cast Shadows

The shadows cast by an object onto another surface are called *cast shadows*. Cast shadows are usually distorted forms of the object that cast them. They lean away from the light source and are affected by changes in the surface on which they are cast. The closer they are to our eye level, the more slender they appear. Their value is determined by the value of the surface on which they fall and the strength and angle of the light. They may contain color reflected back from the object that cast them.

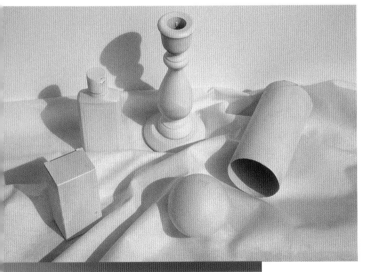

FORM AND CAST SHADOWS
Look at the differences between form shadows and cast shadows. The changes in value are what let you differentiate between the objects and the surfaces of this all-white arrangement.

Create Realism With Light and Shadow

Your world is real. If you want your representation of it to look real, you must first learn how to see. Once you see and understand what you are looking at, it will be easier for you to create the illusion of reality. Part of learning how to see consists of understanding light and shadow, their gradually changing values and the differences in contrast they create. Then you need to be able to smoothly re-create the gradual changes.

The ability to realistically render objects relies on your observation and your ability to reproduce what you see. To render objects realistically, you must create certain illusions that convince viewers they are seeing in three dimensions, when really there are only two. Shading is one of those illusions. Not only must you learn to make smooth gradual changes in value, you must also be able to see and interpret value differences. Understanding value is even more important than understanding color.

16

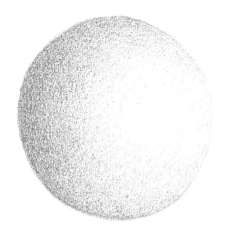

FABRIC FOLDS
Draped or arranged fabric consists of convex and concave tubes or cylinders. These tubes are usually not even, but bent, crinkled, curved and overlapping. The value change is gradual over curves and rounded areas, but where there is an edge, a fold or a crease, the change is sharp and abrupt.

ROUNDED OBJECTS
Smooth gradual shading changes a two-dimensional circle to a three-dimensional sphere. Curved surfaces have gradually changing values with no abrupt changes from dark to light. Shadows curve around rounded objects instead of landing straight across them.

COMPLEX OBJECTS
Carefully observe what shadows do. Where surface curves are gentle, values gradually change. Where edges or sudden surface changes occur, value changes are more abrupt and have greater contrast. An object is capable of casting its own shadow on itself. In that case, the shadow acts as both a form and a cast shadow, and as it follows the surface of the object, it also helps to describe its form.

FLAT SURFACES
Flat surfaces, or planes, usually accept light evenly, but when turned at different angles to the same light source, each plane will be a different value. A flat surface exhibits little (if any) changes in value.

EXPLORE SHADING TOOLS

Carrie Stuart Parks

To understand shading, you need to know three things: What to look for, how to evaluate what you're seeing and any useful techniques to make your drawings better. The only additional tip for shading your drawings is practice. Shading involves hand-eye coordination. Emerging artists have trouble with shading not because it is more technical or difficult than other techniques; they struggle because it requires new physical skills that come with practice.

Shading involves training the eye to see what artists call *value changes*. Value means the lightness or darkness of a color. A value change is where something changes from light to dark, or vice versa. The five skills for great shading involve values and how to:
- Identify
- Isolate
- Compare
- Question
- Seek

Shading techniques

There are many techniques for shading, including varying the pencil direction, making linear strokes, building up lead and smudging the lead. I prefer the shading technique of smudging the lead. Smudging requires a smooth paper surface. It has a few tricky areas, but it's faster and requires less pressure and control of the pencil.

LAYERS

When you smudge, you lift a small part of the lead from one area and transfer it to another. This means that not only are you blending into one area, you are lightening another. Smudging is not a one-time application. You may need to go back and darken the original area again and apply layers of blending to get the right value.

USING A PAPER STUMP

Smudging requires a paper stump or tortillion, a tightly wound cylinder of paper with a sharp point at one end. You use it to pick up lead (graphite) from one area of the drawing and blend it out. The paper needs to be smooth, plate-finish bristol board or illustration board. Textured paper is better for other techniques because it snags the lead.

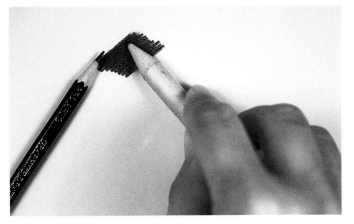

SMUDGING

The lead may come from the drawing itself or by scribbling on a piece of paper with a soft pencil (2B-6B work well). As you pick up lead and move it around with the paper stump, it gradually gets lighter as the lead is worn off the stump. This is why it's easier to smudge—the tool is helping you maintain the correct amount of lead.

Shading with Stumps, Pencils and Graphite

1 Hold the Stump Correctly
This is the standard way you hold your stump for smudging a small area—using the tip. For larger portions, use the stump's tapered side, held flat against the paper. Place it across your flat hand and smudge using the tapered area.

2 Don't Touch!
Your hands contain oils that will transfer to the paper, causing the paper to react with the graphite in adverse ways. Place a piece of tracing paper under your smudging hand as you are working on the details with your mechanical pencil.

3 Retain Some White
Preserve the white areas of your drawing. Remember that you are grinding lead into the paper, and though the paper is smooth and cleans up well, you want to keep from grinding lead into the areas you know will remain white. Work from your dark areas and blend toward your lighter areas using a graphite pencil.

CREATE SMOOTH SKIN

To make the skin on a drawing look smooth, use long smooth strokes on your paper. Short, jerky strokes make for bad skin. If necessary, go outside the edges of the face and erase later. (I know, I know, I just told you to not smudge where you want to retain the white areas, which might be outside the face. That's okay. Sometimes you need to break an art rule to achieve a goal—in this case, smooth skin.)

The same holds true for your original pencil shading—long, smooth strokes applied with an even hand make for smooth skin and hair. I'm starting to feel like a commercial.

19

CREATE TONES BY SMUDGING

John Pickford

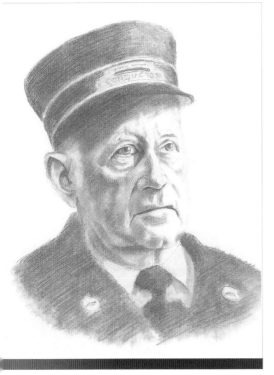

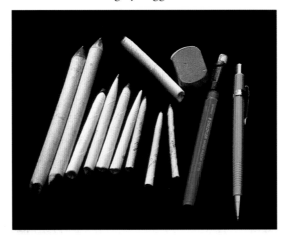

THE SHAPES AND SIZES
Stumps come in a variety of sizes, as you can see here, and those pointed on only one end are officially called tortillions. On the right are a pair of erasers, which are essential for use with a stump.

Smooth, subtle shadings don't seem like the natural strength of drawing media such as graphite and charcoal. In fact, the dryness of the media and the pointedness of their application make these techniques a challenge. But there's a marvelously effective tool that makes it easy for you to create shadings as soft as the tones of a black-and-white photo. It's the rolled-paper stump.

This inexpensive, easily available tool (also called a *stomp*) can range in size from a thin, ⅛-inch (.3cm) diameter "detailer" to a hefty ⅜-inch (1cm) giant. It's held like a pencil and used primarily for blending charcoal or pastels, but it works just as well with pencil drawings. The stump, pointed on both ends, is relatively blunt and firm enough to clean or to sharpen with sandpaper. Its sharper cousin, pointed only on one end, is called the tortillion. It's softer and more useful for drawing lines or creating the softest tones in a drawing. Whichever you choose, you'll find it can be one of your most valuable drawing tools.

A Simple Method

Here's a good procedure: First create a line drawing (I like to use a 0.9mm mechanical pencil) outlining the shape and the shadow areas of your subject, but keep your lines faint. Then rapidly hatch or crosshatch the shadows. Don't worry if some hatch lines spill across your outlines; you can make corrections later with an eraser. Again, keep these lines fairly light, but feel free to use more or darker lines in areas of deeper shadow. Don't build up those darks too quickly in a single area, however. Slower buildup means better control. Also, you'll find that if your hatch lines are close together you'll have an easier time creating smooth tones with your stump.

Next, rub the shadow areas with a stump to blend the hatch lines, turning them into tones. Whether you rub until the lines are completely eliminated (a continuous shading) or leave some lines visible will depend on the results you want. To create the darkest darks, you can re-hatch certain areas to be further rubbed with the stump.

Generally the direction of your hatch lines is unimportant, unless you want some of those lines to show through. Rendering hair is an example. If the lines are thoroughly blended away you'll get what looks like a helmet, so start by hatching in a direction that roughly suggests the hair, without crosshatching. You can even start a drawing of curly hair by making circular scribbles. Then use the stump to rub in the same general direction and, once you've blended the hair, look for variations in tone. Use a flat eraser to gently soften edges and create highlights.

The Tricks of the Trade

Repeated hatching and rubbing is helpful because the stump acts in part as an eraser. It picks up and retains your medium as you use it, getting dirtier and dirtier. A dirty stump can then be used, without hatch lines, to create soft transitions between shadow and light areas, or to create lighter, softer shadows on its own. You can even draw soft lines with a small, dirty stump or tortillion.

Before a drawing is finished, however, you'll usually need another simple, inexpensive tool: the eraser. Just about any kind can be used to correct shapes and to eliminate hatch lines that crossed boundaries. But it can also be used (gently) to soften an area you've made too dark, or—if it's a large eraser—as a sort of super-stump to blend areas where the hatch lines still show.

Finally, it may occur to you that you already have a more natural stump than the paper kind—your finger. Using your finger as a blending tool can be tempting, but the drawback is that it's slightly damp with normal perspiration, and this moisture tends to darken a tone. It also makes erasing or correcting more difficult, and sometimes even impossible. So I recommend only using your finger, if at all, for a final pass over the darker areas. Similarly, avoid letting the side of your hand smudge your drawing while you're working. I keep a piece of clean paper under the side of my hand as I work and avoid leaning too hard on it.

It takes practice to create successful toned drawings, but mastering the stump will get you there much faster, and it's one of the easiest drawing tools to use. It's a blender, an eraser and a drawing instrument all in one. Softness is the key, so keep a light touch and you'll give your drawings the range of tones you've always wanted.

THE PAPER CHOICE

Many different kinds of paper can be used with stumps, but a couple of my favorites are white, 2-ply bristol board with a vellum finish and cold-pressed illustration board. These papers have enough tooth to hold a lot of graphite, but the lines and tones are still easy to erase. Slightly off-white bristol board also works well, but its color reduces the range of possible values. Softer papers, such as those found in most ring-bound pads of drawing paper, are often easier for blending tones, but you'll have to build up your tones more carefully because fewer corrections are possible. After all, no paper can be rubbed, erased and re-rubbed indefinitely.

STUMPING AT WORK

Here you can see a toned drawing in stages. I began by outlining the subject and its principal shadows, then hatching over the shadow areas, as you can see in example A. Then I started blending the hatch lines with a stump around the subject's right eye, aiming for a middle tone except in the deepest shadows, where I'd used the most lines. In example B I continued blending and even added additional lines to darken the deeper shadows, then finally used erasers to lower some tones and create highlights.

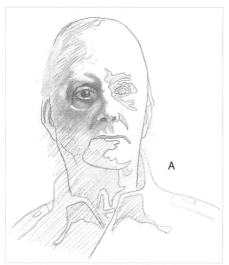

A

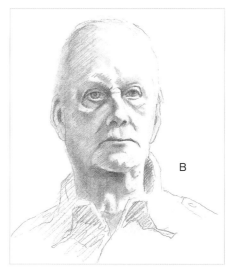

B

21

USE AN ERASER FOR BRIGHTER DRAWINGS

Martha Newfield

Most people begin drawing using erasers only as a correctional tool. But if you limit erasers to that role, you're overlooking their use as powerful drawing tools. An eraser can help you add light, atmosphere and movement to your drawings. By layering or crosshatching, you'll normally build up darks gradually while retaining the light. But it's also possible to work the other way, beginning with the dark tones and subtracting the light with an eraser. I've found that working with the eraser in this way has helped me add drama to my drawings.

Choosing Your Weapon

To begin, you'll need to choose an eraser you can work with comfortably. Most erasers, made from petroleum by-products, are categorized into three types. The gum eraser is firm but soft. It crumbles as it's used and won't damage paper, but will smear such soft media as charcoal or pastel. Rubber erasers, like the white plastic and pink erasers, are best used with graphite. These erasers tend to damage the surface of your paper, but can be cut with a razor blade to create thin, white accent lines.

Finally, the gentle, easy-to-use kneaded eraser is pliable enough to be molded any way you want—from a point to a ball. This long-lasting, nonabrasive eraser works best with soft carbon, charcoal, graphite or pastel drawings. It self-cleanses when you knead it with your fingers and leaves your work space free of eraser dust.

1 Tone the Paper

Begin by covering an entire sheet of paper with charcoal. Use the side of the stick for faster coverage and a soft paper towel to even out the application. Rub the charcoal into the paper so it becomes a rich gray. Be careful it doesn't get too dark.

2 Set Up the Composition and Define the Darkest Shapes

Study your subject carefully to determine the lightest shapes. Use your eraser to create light parts, lifting out the charcoal by shaping the kneaded eraser to a point or a flat edge, so you virtually draw with it as you're erasing the charcoal.

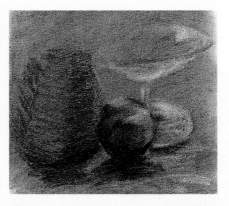

3 Continue to Define the Composition

Putting less pressure on the eraser, define your midtones by lifting out still more charcoal in the appropriate places. Finally, restate the darkest blacks and refine the dark edges to maximize impact. Remember, making use of the full value scale—from the lightest to the darkest tones—will give your subject depth and objects volume, and imbue the entire drawing with atmosphere and light.

With your tool of choice in hand, you're now ready to discover what the eraser can do for you. In a nutshell, you can use it to subtract darker areas and refine them as light. Shaping the edge of the eraser to a point will give you a drawing pencil for creating precise edges.

Seeing the Big Picture

Creating a good drawing requires thinking about every aspect of the picture. Approaching a drawing from dark to light and from large shapes to more detailed shapes will help you think of your drawing as a whole. Isolated objects often look good, but the trouble is integrating them into a coherent space with background.

For example, negative space, the area around an object, should be considered an element in the drawing as much as the positive shape of the objects. With the dark-to-light approach, you're addressing the background and the negative space from the start. With the background on the paper first, you must look at the value instead of the outline when deciding what shape to pull out. This strategy will help you to better conceptualize your work.

Achieving an Expressive Drawing

Labored details and repetition of lines and outlines in a drawing are sometimes interesting, but often don't yield bold, dynamic drawings. Using the eraser as a drawing tool can help you approach a drawing in a different way. Begin by choosing any subject with strong value contrasts, such as a portrait of someone in strong sunlight or an interior lit from the window. Mood and drama can be readily included as you manipulate the bold contrast of lights and darks. In addition, this exercise will train your eye to see the essence of a scene first. So take the eraser challenge and try using it to breathe atmosphere and light into space to yield bolder, more expressive drawings.

ERASE AWAY

The type of eraser you choose depends on which one you prefer and the medium you're using. White plastic erasers and pink erasers can smudge. Kneaded erasers work well with charcoal.

The most dramatic use of the eraser, however, is allowing it to interact with the drawing itself. This technique can be done by using the eraser to make drawing strokes—scribbling, hatching and smudging.

USE ERASER MARKS TO ADD DRAMA
You can make eraser marks across your drawing to create movement or break down defined edges to create atmosphere. For example, in the drawing at left, *Still Life With Fruit*, I used the eraser to rub out marks suggesting light flooding through the window. The eraser helped me energize the drawing.

TIPS FOR DAILY SKETCHING

Butch Krieger

Like many artists, I'm addicted to sketching. I never go anywhere without my sketchbook because I never know when I'll find something intriguing to draw. Over the years, I've found that sketching is an excellent way to keep your drawing skills sharp. This is particularly important if you have a day job and can't set aside much time for your art. (As an instructor, I've found that artists who don't stay active with their art tend to lose touch with it and often drift away from it entirely.)

Traditionally, there are two kinds of sketches: *thumbnails* or *conceptual* sketches, with which you present an image derived from within your own mind, and *field* sketches, in which you record what you actually see. When I talk about sketching here, I'm referring to the latter. Sketching in the field—whether in your backyard or at the local mall—presents wonderful opportunities for discovering the nuances of nature and learning to record them quickly.

The first step in effective sketching is to define exactly what a sketch is—and isn't—and to look at some of the basic skills you'll need to get under your belt to sketch effectively. Sketches are quick drawings intended to capture your visual impression of a moment in time. They're more realistic than gesture drawings and less detailed than renderings. Sketching requires that you modify your expectations. Even if the things you want to sketch are stationary—such as buildings or trees—you'll find that they're forever changing. The patterns of light and shadows change as the sun moves across the sky, disappears behind a cloud or sets beneath the horizon. Therefore, you shouldn't hold your sketches to the same standards of finesse that you would your formal drawing. They need not look like finished works of art.

ALLOW YOURSELF TO MAKE MISTAKES

In sketching, mistakes are inevitable. Even though I've been sketching people for twenty-eight years, I still make some real bloopers, such as this botched drawing of a Cub Scout's face. My sketchbooks are fraught with bungled drawings. It goes with the territory.

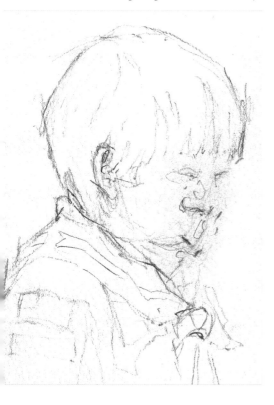

LIMIT YOUR SCOPE

This sketch of my infant daughter, *Bonnie Asleep*, is a good example of scope. I limited the drawing to just her face—the part of her that showed through the opening in her blanket. Had I expanded the picture to include all of her bundled blanket, I'd have lost the focus of attention on her face.

Fundamental Truths

There are four fundamental drawing principles that are indispensable to good sketching:

1. Learn how to use contour lines to represent an edge that you see on the person or object that you're drawing.
2. Develop your understanding of *chiaroscuro*. That is, you must be able to use contrasts of light and dark to model the illusion of three-dimensional forms.
3. Know how to see and use negative shapes (the spaces around the objects) to identify forms.
4. Master the twin principles of perspective—both linear and atmospheric—and foreshortening.

When you feel you're ready to make the transition from rendering to sketching, you'll need to learn how to feel the difference between these two modes of drawing. Simply knowing the distinction between them isn't enough. Sketching requires a different way of thinking than does rendering, and your mind must shift into another gear to do it. To make the mental transition from rendering to sketching, start by copying sketches or other very simple drawings by other artists. There was a time when copying the drawings of master artists was a standard part of art students' training. It was considered indispensable. And the same principle can help you here. Copying the sketches of other artists will teach you how that particular artist did it and help give you a feel for sketching. Try to do it without drawing aids, such as grid systems. You won't be able to use them when sketching from life, so don't let yourself get dependent upon them.

Your best choice for artists to copy are those who draw the same things that you want to draw. Whatever your chosen subject may be, there's probably some artist who's published a book on it.

DEPTH: A BASIC REQUIREMENT
No matter what subject you choose, you should have a good sense of depth in your imagery. In the figure above, for instance, the illusion of a three-dimensional form was essential to the success of the drawing.

KEEP YOUR EYES OPEN FOR SKETCH POSSIBILITIES
Opportunism is a key element to successful sketching—particularly if your chosen subject is people. I drew the two images at left on a boat ride from Victoria, British Columbia, to Seattle. It was at the end of a long day, and many of my fellow passengers fell asleep during the ride. So I sketched several of them.

Increase the Pace

Once you understand the basics of drawing, you're ready to consider the matter of speed. Fortunately, speed is easy to learn—much of it is simply a matter of learning what to leave out of your drawing. Rapid drawing doesn't require any special gifts of manual dexterity. It's just a matter of practice and adopting some simple strategies. For example, decide the scope of each sketch before you start drawing. Determine how much of the subject you want to draw and how much of the surrounding visual environment you'll include. Remember that the less you add, the faster you can draw.

Although you can't expect the quality of your field sketches to match that of your careful renderings, you still want your drawings to look right. So when you're first learning to sketch, try to increase your speed as much as you can without sacrificing the quality of your results. Build up your rate of speed slowly. Choose something to draw, then give yourself a time constraint within which to complete the sketch— perhaps ten minutes. When the sketch is complete, draw the same subject again, this time in five minutes. Then do it again in three minutes. Each time around, increase your speed, not by narrowing the scope of your sketch—but by swifter hand movement and simplification of details.

Don't Fear Failure

The final step in preparing to make good field sketches may well be the most difficult: overcoming your fear of failure. Your motto must be "full speed ahead." Accept the fact that it isn't possible to draw without errors. There's no way around this. If you decide to wait until you get good at it before you start sketching, you'll never do it.

There are some things you can do to lessen the risk of failure, however. First, use a forgiving medium. I recommend a graphite pencil and a good eraser. Don't use ink or felt markers. They're permanent, a fact that can introduce hesitation into every line.

Working with a limited focus is another great way to decrease your fear of failure. The greater the scope of your sketch, the more likely you are to botch it up. So start small. For instance, if you like to sketch faces, limit your focus to individual features, such as noses or ears. Or if you like to draw trees, begin by sketching parts of trees. Then as you gain experience, you can expand your scope. I also suggest keeping your actual drawings small.

EXPERIMENT WITH COLOR
This is a watercolor sketch I did of a friend. The use of color adds another dimension to sketching, but it also complicates things considerably. It's a good idea to master the art of sketching in black and white (or at least monochrome) before you introduce color.

Larger drawings take longer to do because you've given yourself more area to cover. And with a larger sketch, you may find yourself trying to add too much detail.

Finally, if you choose to use a sketchbook, start with the spiral-bound kind. Most of us fear failure because we dread the thought that someone else will see our mistakes. With a spiral-bound book, you can separate the triumphs from the flops—and throw the bad ones away.

Be Here Now

You need not go to faraway, exotic places to find subjects to draw. You might go to a nearby park and sketch someone snoozing in the shade of an old oak tree. Or you might go to a historic part of your city and sketch a quaint old Victorian house. Whatever subject you choose, you'll find that sketching is one of the most pleasurable—and educational—experiences an artist can have.

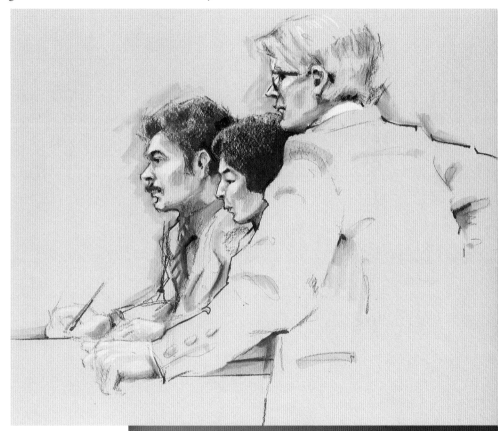

SPEED IS AN IMPORTANT ASPECT OF SKETCHING
I did this television courtroom illustration, *Kwan Mak Sentencing* (colored pencil, 9 x 12 [23cm x 30cm]), in just eight minutes. Some of the things I did to accelerate it are rather self-evident. I left the background elements out entirely and used merely three parallel lines to suggest the judicial bar at which the three people were standing. I omitted much of the right arm of the closest man, simplified the detail of his coat and streamlined the hands considerably. You can see that the colored-pencil shading is rather rough. Note, too, that I had some difficulty drawing the right collar, shoulder and upper sleeve of the man farthest away from me. I knew they were in there somewhere, yet I never did get them quite right.

CREATE A COMPLETE SKETCH

Jerry McClish

Unless a painting's basic sketch is reasonably correct, the finished painting won't turn out—no matter how adept the artist is with a brush. Perhaps the reason some artists are turned off by drawing is that there's only black, shades of gray and the white of the paper. But approached in the right manner, these tones can produce excellent guidelines for color paintings, as well as exciting works of art in their own right. There's a sense of accomplishment after making a drawing that has a good composition and really says something—it encourages me to pick up a brush and repeat it in color when I return to my studio.

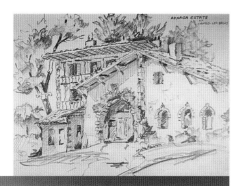

BUILD A SOLID FOUNDATION
While traveling through the village of Cambo Les Bains in central France, we saw Arnaga Estates. It's a very large castle and there was no way it would fit in my sketchbook as a simple sketch. The gardener's house, on the other hand, made an interesting subject, so I used it to make a value sketch (top). There were just enough varied details and overlapping planes to make a composition.

Back at my studio after the trip, I painted *Arnaga Garden House* (watercolor, 22 x 30 [56cm x 76cm]) from my sketch. Some of the ornate details were simplified and texture was added in many places, but I kept the shadows as drawn because they fit the composition.

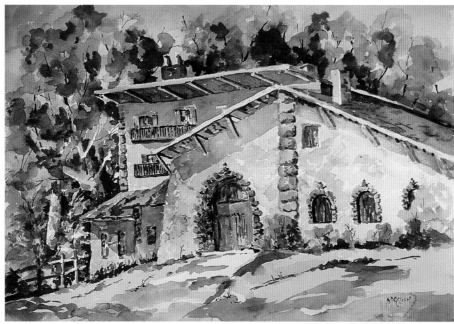

Getting It Down on Paper

The key to sketching on location is making sure you get the information you need. These details will, in turn, help you create a good painting. In a nutshell, a sketch should include the following five elements:

Center of interest: A sketch usually begins somewhere around the focal point, but there's no rule that says you have to have one center of interest. You can have a divided center of interest, multiple centers with one or two outstanding objects, or you can have what's known as a wallpaper pattern with scattered focal points all over the page. Whatever you decide, the center of interest is where you'll have the most detail, as well as the strongest value contrasts. It's best not to have any center of interest or intricate details near the edge of the composition, because that can lead the viewer's eye right out of the drawing.

Horizon line: Early on you'll also want to establish a horizon line or eye level for your sketch. Besides helping with the general composition, this line can also help with perspective.

Depth: To create a sense of three-dimensionality, pay attention to perspective and overlap your shapes. Many books have been written on the subject of perspective because

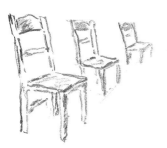

it encompasses so much—linear perspective, vanishing points and aerial perspective, for starters. At the very least, you should know that proper perspective ensures that objects get smaller in size as they recede into the distance, as in this sketch of the chairs.

Overlapping your subjects can also produce a sense of depth. Two or more objects of any size side by side leaves a question of which is closer to the viewer.

Value: Basically, value refers to the light and dark areas in a drawing or painting. Using several different values in your artwork can help your drawings in a variety of ways. First, values in a sketch show the direction of incoming light and set up the shadow planes and patterns. When adding shadows, be sure their angles agree. For instance, if you sketch the same subject at different times of day, you'll find your shadow angles won't be consistent.

Second, value can help emphasize the focal point by making the lightest light area and darkest dark area abut. There may be other light and dark areas, but they won't touch each other. In the drawing of the house on the opposite page, for example, the white of the sidewalk abuts the dark shape of the front door, which emphasizes the center of interest.

Finally, changing value on a receding plane helps create a third dimension. You can use different values to make the sides of your subjects appear to come forward or recede.

Texture: Varying the texture of your subjects will add interest to your art, as well as show dimension. You wouldn't, after all, want a painting with all smooth surfaces or all rough surfaces. As for adding dimension, a nearby textured surface can be quite detailed. As it goes into the distance, it loses definition and value and decreases in size.

Finishing It Up

These five elements may be a lot to remember as you're sketching, but by drawing your subject first, you'll solve a lot of problems before you start painting. Another thing you'll want to keep in mind as you're drawing is to slowly build up the composition, rather than finishing one small section and then moving on to another section. On the same note, to keep your piece from becoming overdone, build up details slowly or save them until the end to make sure you really need them.

When you're ready to copy your drawing onto your painting surface, keep the underdrawing simple, without any values and only hints at future details. Remember that you can alter your drawing as you put it on your painting surface, such as changing the direction the light is coming from or adding and eliminating objects. As you paint, you can continually look back to your sketch.

There are few paintings I've done that I didn't first draw out the composition and pay attention to the center of interest, horizon line, depth, value and texture. Try it and see what it can do for your work.

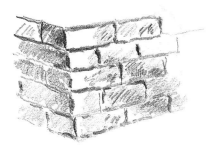

ADDING TEXTURE FOR INTEREST AND DIMENSION
In this drawing of a corner of a brick wall, the definition is strong close up but dims and becomes obscure as it recedes.

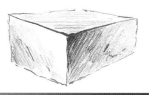

USING VALUE TO CREATE THREE DIMENSIONS
On this box the light is coming from above and to the left, so that means the sides of the box closest to the light will be lighter than the sides farther away from the light—although it's not so simple as to leave each side with a nonvarying value. Notice that on a light plane (the left), the lightest light is closest to you and gets darker as it recedes. On the darker plane (the right), the darkest area is closest to you and gets lighter in value as it recedes.

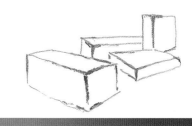

CREATE DEPTH BY OVERLAPPING
In this drawing of multiple boxes, you can tell which one is in front and which is in back because they are overlapped.

A RANGE OF STROKES
To keep things interesting in your sketches, remember that a line doesn't have to be straight and unbroken. It can wander a little, have breaks and vary in value and width. A small zigzag in a line can still say "line" and break the monotony. Value patches may have angled, straight, crosshatched or overlaid patterns. Experiment and see if you can find new or different techniques that can be adapted to the use of a pencil.

DRAW YOUR MEMORIES REALISTICALLY

Butch Krieger

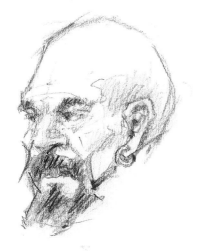

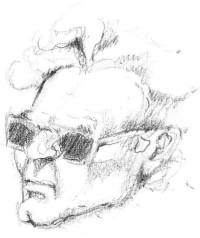

As artists, we've probably all wished for photographic memories. If only we could take a mental snapshot of whatever we choose then, later, in the comfort of our own studios, we could re-create the image with stunning clarity and realism. While you may not have been born that lucky, you can hone the memory skills you do have in order to better retain images from the world around you. And in doing so, you can bring the world into your studio.

Memory training was once an indispensable part of every artist's discipline. During the last century, however, with the advent of photography and the lack of emphasis on drawing skills within the art industry, this part of an artist's education virtually disappeared. In my workshops on sketching people, however, I include memory practice as a fundamental part of my instruction. Image retention can be lengthened with exercise, much like exercising your muscles makes them stronger. And the longer you can retain an image, the less often you'll have to interrupt the act of drawing to look back at your subject to refresh your mind's eye. So here are a few ways to do some training at home.

Start Simple

Start by choosing an object from which you can do a simple line drawing, preferably one that has clear, distinct edges, such as a crumpled piece of drawing paper or a kitchen utensil. (I recommend you omit any shading at this point—stay strictly with edge lines.) Set yourself up to draw this prop just as you normally would: Pick a spot on the object where you wish to start drawing and hold your pencil tip to the paper, ready to draw. Observe the object, focusing your attention on that spot. Then close your eyes and draw the object from the image you see in your mind, but your eyes must remain shut while you're rendering the lines. This is important—really push yourself to keep drawing from that mental image as long as possible before you take another look.

When you can no longer see the shapes in your mind, open your eyes for an accuracy check. If you find that your line has gone astray, don't bother erasing it—that's not what matters right now. Just go back to the place where you began to go wrong and start again from that point. Finish the entire drawing in this manner, looking at the object and then closing your eyes while you draw it. The procedure may be a little awkward at first, and you may not do your best drawing this way, but it will prove to be valuable training for your visual memory.

A WORLD OF SUBJECTS
There's no shortage of interesting faces to draw, and you need not go to distant or exotic places to find them. I drew these small vignettes of men who walked by my car while I was waiting in a parking lot. As each of them passed, I took some quick mental snapshots and immediately sketched an image while it was still fresh in my mind. This technique enables me to draw many interesting faces that I otherwise would miss.

Push Your Limits

After repeating this procedure with several objects, you can reuse them for the second exercise and keep your eyes open. You must, however, set up each prop so that some time passes between your looking at it and drawing it. Try placing your prop behind you, forcing yourself to turn around to look at it and then turning back around to draw it.

As you get better at this, try to stretch yourself even more by placing the object in another part of the house, for example. This will oblige you to leave your drawing behind while you go into the other room to look at the prop. The trek between object and sketch will also force you to retain that mental picture longer. Eventually, you should get comfortable adding a variety of shadings to your drawings as well.

Go For Detail

Next, to really take your memory sketches to a higher level, try the more detailed observation of portraits. Begin with someone in close proximity so you can return to the face as a reference point, as you did in the first exercise. Retaining the shapes of such things as hats and hairdos is often a difficult task, one that demands extra attention, so take the time to examine your subject very carefully. Also be sure to note the type and angle of the main light source. Once you've turned your eyes from your subject, begin the sketch.

Block out the major shapes in the face and head, looking back at your subject only when it's absolutely necessary, then fill in the more minor details and decide where the shadows should fall. Lastly, fine-tune your shading and add the finishing touches. With practice, you'll be able to allow more and more time between viewing and drawing.

All this training will prepare you for one of the best artistic experiences available, which is to take your skills out of the studio and onto the streets. You'll be ready for any enticing subject you encounter, either sketching passersby on the spot or mentally taking their images back with you to your studio. Once you learn to commit details to memory and begin to push your memory to its limits, you'll find that drawing has become more fun than ever.

THREE STEPS FOR SKETCHING PORTRAITS FROM MEMORY

1 Several hours after studying this man's profile as best I could in a large department store, I blocked out the

major shapes of his face and head. But no memory is perfect, and at this point I discovered that my memory of the shape of the turban was somewhat unclear. So I drew that area vaguely and concentrated on the areas of greater interest. You can also use a little creative interpretation in situations like this, however.

2 Next I filled in some minor details of the face, eye and ear and determined where the shadows would be.

In this stage you have some leeway to be creative, but it's also in these details that a real sense of character comes through, so you'll have to balance your own interpretations against the clarity of your memory.

3 I completed the drawing by filling in the shadows and adding some final details. Although I had observed the

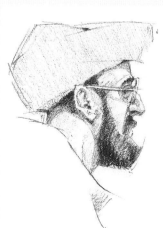

man in diffused light, the main source of illumination was the overhead ceiling lamps. This provided me with some shadows that I used to develop the illusion of three dimensions in the sketch.

USE A SCALE TO CONTROL VALUES

Bill Tilton

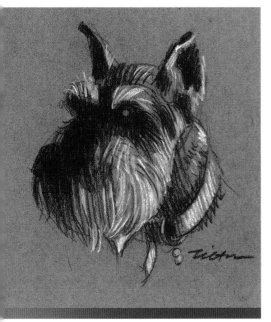

MAKE MORE WITH LESS

You don't have to use a great many values to produce a convincing drawing—this schnauzer is composed of mostly black with touches of white, and the brown paper serves as a middle tone.

As representational artists, we want our subjects to make convincing impressions. To do this, we learn to establish relative sizes and create the illusion of space and mass, but when we add the skillful use of values, our work gains real vitality. Much advice has been given about the importance of careful attention to values and the benefit it brings to your drawings, but you can't get too much of a good thing!

Values are easier to understand and much easier to use than many aspiring artists realize. Simply stated, value is the relative lightness or darkness of a mark or of a plane from a specific point of view. Many values combine to give your subject a certain look in a certain position and light. The better your awareness of these values and the better your ability to draw and paint them, the better your final result will be—all the more so when accurate values are coupled with your accurate rendering of mass, shape, texture and relative scale.

Use a Value Scale

A significant obstacle to seeing the values of objects is that vivid colors tend to be difficult to translate into comparable shades of black and white. If we could look at our subjects in their actual color and magically see shades of black and white, accurate rendering would be very simple. Drawing from plaster casts teaches you how to see values clearly, thereby enabling you to make accurate renditions of whatever you're drawing. This method is a time-honored and essential part of traditional academic art teaching. Absent good plaster casts, working with quality black-and-white photographs is a good learning method. One of the best tools for sharpening your value focus, however, is the value chart.

A useful value chart is easy to make, traditionally being made up of ten values from white to black. Here's what I recommend: Start with a small piece of 5-ply or stronger illustration board or matboard that's 2" or 3" wide (5cm or 8cm) and 10" (25cm) long, and mark it into ten segments. Use acrylic paint to make one end white and the other black, and then use mixtures of these colors to progressively fill the remaining spaces. The measurement of each mixture and the total number of segments may be arbitrary, but this method should allow you to create a satisfactory range (see my value scale below).

LAY VALUES OUT

This simple scale of ten values from white to black is all you need to get the right value balance in your drawings.

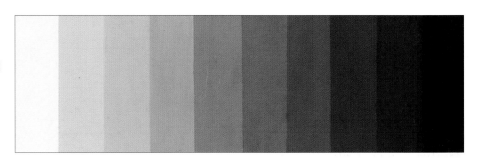

The Technique

This scale allows you to do a number of important things easily. With it, you can judge at a glance the full range of your subjects' values. For example, after you mix a color you can find its value on the scale where its edge appears to blend with one of the segments. You can even use it to identify the values of a potential subject, whether it's a reference photo or a real object. I've used two scales—the one described here and one created on a strip of clear plastic, which allows me to lay it directly over my work. (To help the paint adhere, paint the plastic first with acrylic medium mixed with a bit of ox gall.)

When painting, many artists premix their values, applying paint in a straight-from-the-tube thickness, but I generally prefer the thin, multilayered approach. As each layer dries, I have the pleasure of watching the values develop. With enough drawing practice, you eventually might no longer need a value chart and instead may use thumbnail sketches to determine whether the finished drawing will be more effective in the low (dark) or high (light) value key.

The value range and pattern of your final drawings depends on your concept and your personal style, from simple line drawings with very few values to highly detailed realism running the entire gamut of values. But you'll find you can draw almost anything with the standard ten-value system. It's been the backbone of virtually every great example of representational art, including chiaroscuro, etchings, lithographs and paintings or drawings of every medium. Take time to absorb the value system and the work you produce will be more valuable for it.

FIND YOUR RANGE

Thumbnail sketches are a great way to find the right value pattern. Here I tested both a high-key and a low-key rendering for this raccoon and made a quick sketch to identify the lightest and darkest areas before creating the final drawing with a full range of values.

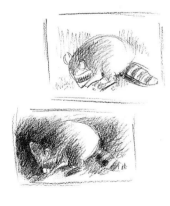

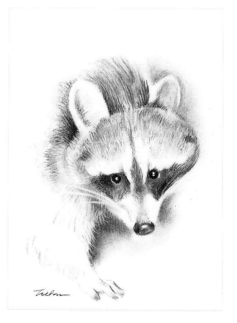

ADJUST YOUR VALUES

Butch Krieger

START WITH THE BACKGROUND
To get the correct values in your work, you must first consider the background of the subject you're drawing—it's virtually always darker than your drawing paper. In this example, I solved the problem by using the paper for my lightest light and then lightened the remaining values so they looked right in relation to one another.

Judging values is one of the most basic challenges in representational drawing. It's also one of the most elusive to master. The reason is simple: Values—the perceived lightness or darkness of an object or area—are entirely relative. How light or dark something appears depends very much on its environment. For example, if you see an object in relatively light surroundings, it will look darker; conversely, if you see the same object in a darker setting, it will look lighter. The trick lies in making values relate to each other so they look "right."

When discussing values, lighter areas are considered "higher" in value, white being the highest possible. Darker values are said to be "lower," black being the very lowest. Along with the term *value*, you'll often hear the word *key*. Key refers to the *average* of the values within a given piece. For example, if a drawing is predominantly light, it's said to be in a high key. In contrast, predominantly dark drawings are said to be in a low key. Now, let's get started.

Adjust Values to Background

The moment you first touch your pencil to your drawing surface, you begin making value decisions. To begin with, in most cases, you'll be seeing your models or props in a visual environment that's considerably lower in key than your pristine, white drawing paper. So the first problem involves allowing for shifts in the general value of your background. If you fail to do this, the images, now isolated on white paper, will look too dark.

The solution to this problem is simple—adjust the values in your drawings so they're correct in relation to your background. You can do this in two ways. The simplest, easiest solution is to draw the image lighter than you actually see it. To do this, substitute the white of your paper for the lightest value and make the other values correspondingly lighter. Your other option is to shade the area around your model or props until it matches the value of the actual background.

Either way, throughout the drawing process, the image will be evolving. The key is gradually getting lower, or darker. Thus, any shading you do at the beginning will take on a different look once you shade the adjacent areas. In fact, the whole process of representational drawing is a matter of adjusting and readjusting as you go along. Because of this, it's a good idea to start with a light, easy touch. Save the heavier shading for the end of the piece. It's easier—not to mention cleaner—to darken an area that's too light than it is to lighten an area after you've darkened it too much.

If you must lighten something, however, don't hesitate to do so—that's why you have a kneaded eraser. Press it gently and lift out the excess shading. Avoid using the rub-it-out types of erasers, and don't think of your eraser as an emergency device that's only useful for correcting mistakes. See it for what it is—a valuable tool for carefully developing the subtle contrasts of lights and darks as you work through the process of assessing and reassessing the arrangement of values in your drawing.

Exercise the Principle

To help sharpen my ability to make these kinds of value adjustments, I developed an exercise based on the value scale, or gray scale. It has been a great help in teaching my college drawing classes, and I'm sure it will work for you as well. To do it, you'll need a soft graphite pencil, such as a 4B, a white sheet of paper and a kneaded eraser to lift out excess graphite as you make adjustments in shading. Begin by drawing a horizontal band of nine small squares. Next, shade in one of the end squares as heavily as possible. Graphite isn't a true black, so your lowest value will be a very dark gray. Leave the square on the opposite end of the band untouched throughout the entire exercise, letting the white of your paper serve as the highest value.

Now that you've established your extreme values, shade the middle square down to a gray that's halfway between the values of the two end squares. Try to be as accurate as you can. Remember, this won't be your last chance to get it exactly right—you'll have lots more opportunities to re-evaluate the relationships and make adjustments as you progress through the exercise. Next, move to the boxes that are halfway between the middle square and each of the end squares, and shade them until their values are halfway between the established values on each side of them.

Finally, fill in the remaining four boxes, each with a shade that's halfway between its neighboring two values. Once all of these values are in place, compare the values and make any adjustments necessary to ensure a uniform flow from one end of the value scale to the next. In the end, you should have a measured, consistent nine-step scale.

MAKE A VALUE SCALE

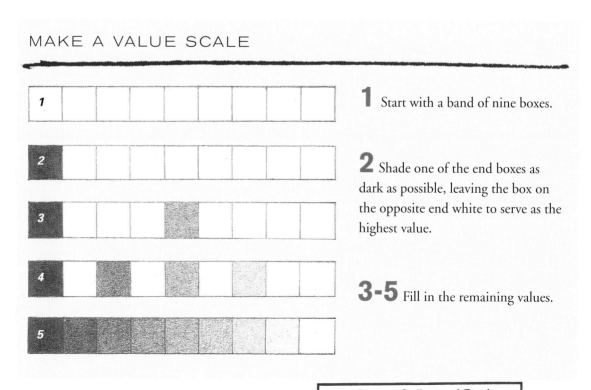

1 Start with a band of nine boxes.

2 Shade one of the end boxes as dark as possible, leaving the box on the opposite end white to serve as the highest value.

3-5 Fill in the remaining values.

ILLUMINATE YOUR SCENES WITH LIGHT

Jerry McClish

Light literally brings a picture to life. Not only does it reveal the shapes and colors of the objects in your scene, but when used correctly, it can enhance the overall composition of your drawing or painting. Thus, it's essential for you to understand the different types of lighting conditions and their effects on your subjects so you can use light to improve your art. You can begin by learning about the six main types of light sources, plus the resulting reflected light.

Six Types of Light

Front light. Front light isn't the most visually pleasing type of lighting because it eliminates and hides shadows, as you can see in the barn sketch (below left). Without the introduction of a definite light and dark side, the change of planes isn't evident. This tends to flatten everything in a scene, so it's difficult to achieve the illusion of a third dimension.

Front-quarter light. Positioned as if it's coming over your shoulder, front-quarter light separates the planes into light and dark areas. The shadow patterns created by this type of light clearly define the shapes and forms of the objects, such as the lighthouse in the sketch (opposite page), and add interest to the overall design. Because it's so easy to understand and re-create on your surface, front-quarter light is probably the most commonly used type of lighting.

Sidelight. Since sidelight puts a greater emphasis on the light and dark sides of objects, it can be a bit trickier to handle. For instance, you don't want the strictly half-light-and-half-dark images to become monotonous. Thus, with sidelight, it's important to pay attention to your cast shadows. Use cast shadows to add balance and variety to the scene, as I did in the forest sketch (opposite page).

Three-quarter backlight. This type of light comes from a 45-degree angle behind the subject, either to the left or right, as in the farm buildings sketch below. With this light source, lighted areas of objects usually appear as thin, vertical slivers while the major portion of the scene is in shadow. When used effectively, three-quarter backlight can add impact and drama to any subject.

FRONT LIGHT
In this sketch, the barn is bathed in full front light coming from a low light source. The angle of the light gave a little deeper value to the angled roofs because they deflect the light up, not back into the viewer's eye. To help separate the different planes, I used diagonal shading to exaggerate the value changes on some of the walls.

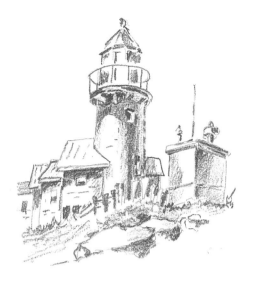

FRONT-QUARTER LIGHT
Here, the light was coming from a 45-degree angle behind my left shoulder. This front-quarter light created an attractive pattern of light and dark areas, which helped to define the changes of flat planes, as well as the curved shape of the lighthouse.

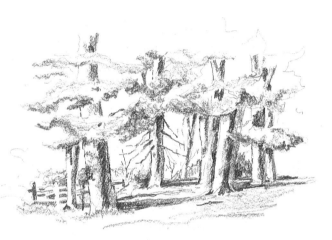

SIDELIGHT
In this forest scene, a direct sidelight bathes one side of each tree trunk in light and throws the far sides into darkness. The shadows march straight across the composition, so I varied the direction and shape of the cast shadows for balance. I also placed some dark value patches of background foliage next to the lighted side of some of the tree trunks to add depth to the scene.

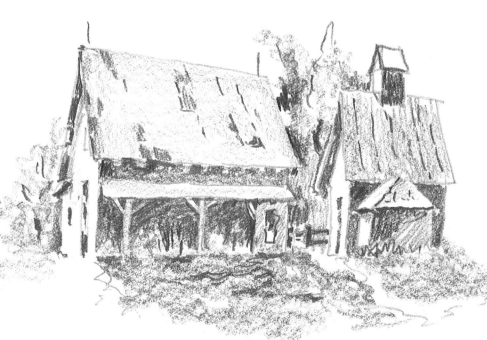

THREE-QUARTER BACKLIGHT
The little slivers of brilliant light against the larger shadowed sides of the objects facing you create an aura of excitement. I deliberately positioned myself a little to the left of the buildings in this scene to take advantage of this effect. But since three-quarter backlighting usually only happens in the early morning or late afternoon under rapidly changing conditions, I had to work fast.

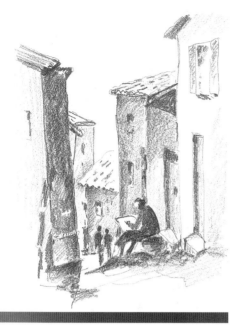

Backlight. In most instances, backlighting is simply a silhouette. You might think that backlight would destroy most of the details by throwing objects into deep shadow. But you can retain the suggestion of form by varying the darkest shadow areas, even though there's a minimal change in value or color. Notice how I've varied the intensity of my dark shadows around the artist in my sketch at left.

Top light. Under what I call "high noon on the prairie" light, objects or buildings will be mostly in shadow, with the exception of the uppermost horizontal planes. True top light does not normally exist in natural settings, at least not in the United States. Even as the sun crosses overhead at noon during the summer, it's still coming from a southern angle. However, top light can be generated in the studio, and used to create interesting, unusual shadow patterns.

Experiment with Light

As you become more familiar with the effects of the different light conditions through practice, you can begin to experiment. Suggest an unusual angle for the light source by lengthening the cast shadows to imply a low angle or shortening the cast shadows to create a higher, overhead angle. Try painting reflected light. A strong light shining on a light or bright object typically "reflects" or bounces off that object onto nearby objects. Just make sure to establish where the light comes from early in the process and stick with that decision as your composition develops, and you'll have a fun and successful endeavor discovering the type of light you find most appealing and appropriate to your subject.

BACKLIGHT
In this scene from a watercolor workshop in Italy, backlight came streaming up the narrow twisting street, placing the artist in almost complete silhouette. To help the composition, I angled the foreground building a little so it received some light. Then I used reflected light to temper the dark values in the deepest shadows.

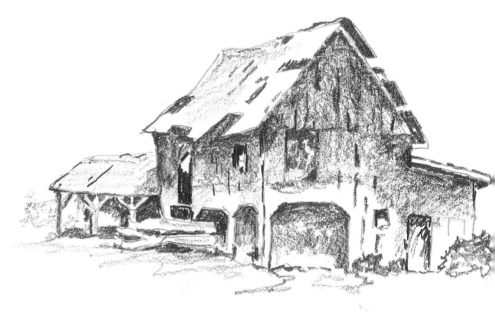

TOP LIGHT
To indicate that the sun is high and nearly overhead, I intensified the shadows under the barn's eaves, allowing them to get progressively lighter as they moved down the walls. These long cast shadows on the vertical walls of the barn say "high noon."

LIGHT FROM SKETCH
TO DRAWING

David Rankin

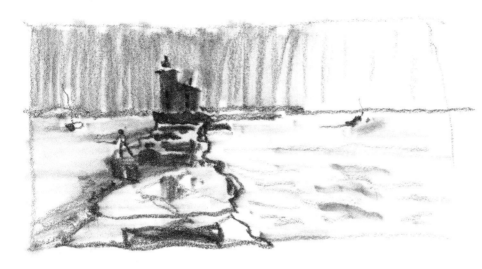

LIGHT IN LANDSCAPES

Light is the dominant factor in all landscape work. In this instance, I had driven to Fairport Harbor to sketch and paint the lighthouse that guards the opening into the Grand River. A summer thunderstorm had just blown through and provided a dramatic quality of light to the whole scene. The painting below shows the sky and light an hour later.

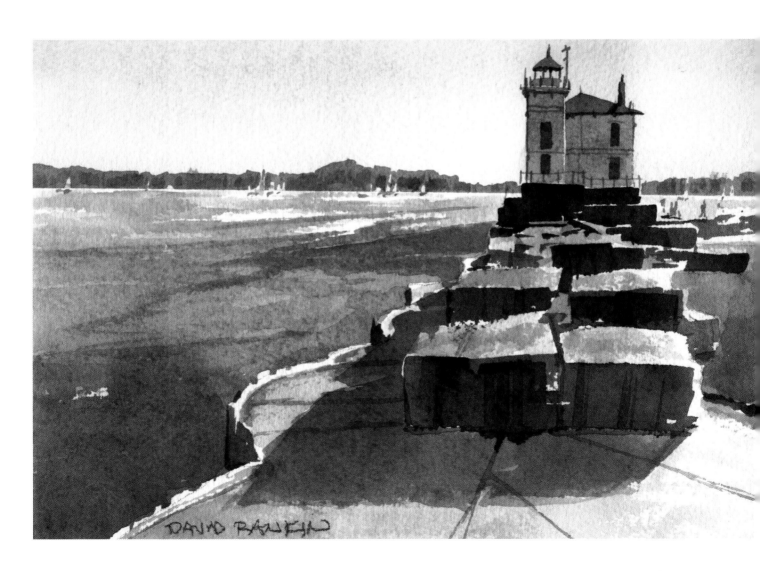

MASTER THE SUBTLETIES OF SHADOW

Butch Krieger

No matter what your subject, cast shadows are an indispensable part of realistic drawing. They optically relate different objects to each other in space and help create an illusion of depth that's critical for convincing artwork. Of course, unraveling a complex arrangement of shadows may initially seem intimidating. But it doesn't have to be. The secret to re-creating accurate cast shadows lies in seeing them correctly before beginning to draw. Once you can see them, the rest is easy. The following set of exercises is designed to set you on the road to seeing, then creating, accurate shadows. Here's how the process works.

Get Focused

First, gather up a variety of objects to use as props. Put one of these items on a relatively large, flat surface, such as the floor or a tabletop. Be sure that you leave enough room on this surface to accommodate the shadows cast by your subject. I recommend using simple props such as a ball or an opaque drinking glass at first. The goal is to learn as easily and naturally as possible, so leave the more complex objects for later. Don't worry about drawing at this point—you'll want to concentrate all of your powers of observation on the shadows. In particular, you want to learn to see shadows as actual shapes, rather than as undefined areas of darkness.

Start your study by illuminating one of the items with a single source of bright light. A studio floodlight is optimal for this, but a regular household lamp with the shade removed will also suffice. Next, eliminate all other sources of light, then shine your light source on the prop at close range. Observe the cast shadow, comparing and contrasting any variations that you find within this shadow and around its border.

Now, move your lamp farther from the object and notice any changes that occur in the shadow. You'll find that the variations within the shadow increase as the distance widens between the lamp and the object.

Next, try these same exercises with more complex articles. Explore other lighting sources, as well. For example, try adding a secondary source of illumination, such as reflected light. Under these conditions, the prop itself may bounce some light into its own shadow, changing its appearance. Nearby objects may also reflect light into a cast shadow.

SET THE MOOD
Use shadows to add drama to your work. In this study for a painting, notice how the long, unbroken shadow suggests that the woman is all alone. Also, observe that the edges of the shadow blur and fade as they recede farther into the distance.

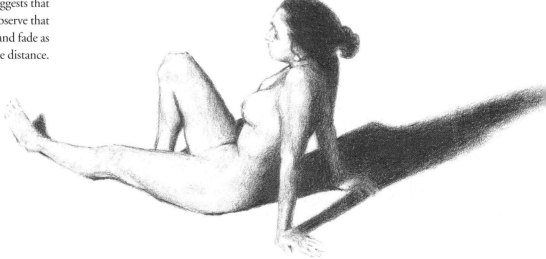

As your ability to see shadows improves, experiment with even more diffuse lighting. For example, you may want to turn on the actual room lights. Or place a number of props on a flat surface and study the shadows they throw on one another. How about a shadow cast on a wall, or half on a table and half on the wall? You'll soon discover that there's no end to the variety of intriguing shapes you can create with cast shadows.

Add the Shadows

When you've finished these observation exercises, you're ready to go back and draw some of those cast shadows. To make this as easy as possible, start with a simple shadow that's cast either to the right or left. Avoid foreshortened shadows at first. Use a medium that can be easily blended with a kneaded eraser, such as graphite, charcoal or Conté crayon, and try isolating each of the shadows by omitting the object that's projecting it. Begin your drawing at the point nearest the source of the shadow and work outward. Add the shading lightly at first. You can make adjustments and darken areas once you've captured the entire shape.

As you try to faithfully render the subtlety of shape and shading that you see, you'll discover that cast shadows aren't nearly as monotonously solid as you may have thought them to be. For instance, the part of a shadow's silhouette closest to its source usually has a sharp edge. But unless the shadow is very short, its outer perimeter becomes softer and more blurred as you move farther from the source. And if there's an abundance of ambient light, a long cast shadow will get lighter as it moves farther from its source. It may even fade out completely.

Develop Your Skills

Your ability to draw is directly tied to your ability to see. If you improve your observational habits, your drawing will improve as well. So take your time as you move through the exercises presented in this article. Be patient. Your goal is to see more completely, which will help you create powerful, expressive art.

CREATE THREE DIMENSIONS
The cast shadows on this woman's face and neck give us visual clues that lead to the perception of three dimensions. Use shadows to define the shapes of faces.

The light source in this drawing is high and to the woman's right. Some of the light filters through the wispy locks of her hair, leaving delicate shadows that cascade over her forehead. The ridge of her eyebrow casts a shadow all the way across the cheek beneath it. The shadow of her nose falls down across her face and merges with another shadow under the side of her lip. Likewise, her jawline throws a shadow down across her neck. All of these cast shadows work together to visually define her facial features as three-dimensional forms in space.

USE SHADOWS TO MAKE REALISTIC LIGHT

Jerry McClish

For any composition, whether it's a painting, sketch or detailed drawing, the addition of shadows can determine its success or failure. When you have light, you have shadow—this principle is essential to realism and is key to giving a picture an exciting sense of life. Here are some of the easiest ways to give those shadows in your drawings the attention they deserve.

Follow the Light

There are two basic types of shadows: the cast shadow, which is found on a surface where the light is blocked by another object, and the shadow side of an object, which simply doesn't face the light source. For cast shadows, the direction of the cast is crucial, and it depends on the direction and distance of the incoming light. When the light source is very distant (typically the sun), all its shadows should follow the same angle. When it's very near, such as an interior light, the shadows will splay out in various directions because the objects in the picture are at different angles to the light source. The drawings of the fence on the next page illustrate the difference.

A cast shadow from any object starts out darker than the object casting it. With a vase sitting on a table, for instance, the area of the cast shadow adjacent to the base of the vase will be darker than the vase, and will also be the darkest area of the cast shadow. As the shadow recedes, a reversal occurs and it becomes lighter than the object causing the shadow. Be aware, too, that the surface the shadow is cast upon can distort its shape.

Also, the definition diminishes and the edges get fuzzy as the shadow recedes; a long shadow cast by the sun can just disappear into the distance. In other words, the greater the distance between the object and its cast shadow, the less definition the shadow has. If the vase casts a shadow on a wall immediately next to it, the shadow will be sharp-edged, but a far wall would show a much lighter and less distinct shadow.

USE SHADOWS TO IMPLY SETTING
Shadows can give a clear indication of the sun's position—here it's high and to the near left—to better inform viewers of the setting.

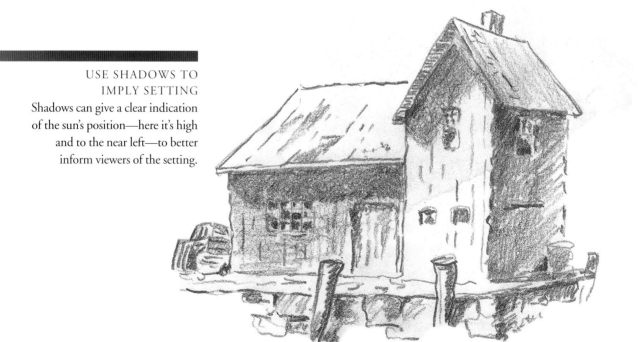

Define Shape

The shadow side of an object provides a great opportunity to describe its shape, especially when it has curves. With a box, for example, it's not too hard to create the line where the sunlit side meets the shadow plane, but with curves there's no definite point of transition. The indefinite line where the gradual transition is made is called the projection edge; it's the darkest portion of the shadow, and it's where the on-coming light skims past the object. As you go around to the shadow side of the lighthouse (below), the value becomes a little lighter, usually due to distance and backlighting. This tells us that the object is round.

Varying the direction of your strokes will help to define the shadows in your drawing. Shadows under eaves, for instance, may have pencil strokes running in the same direction as the incoming light, and long strokes can create the appearance of an elongated shadow. There can be a combination of line directions on highly textured surfaces, and some curving lines can emphasize the curvature of the walls. You might also find that just a series of horizontal parallel lines is effective, with the values changing as the shadow changes.

Your best guide to accuracy will always be careful observation of real life, where you'll never run out of fascinating shadows to study. Keep a close eye on the values, have fun, and remember that the right shadows can do more for your drawings than most of us realize.

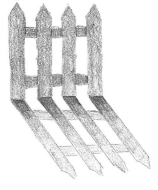

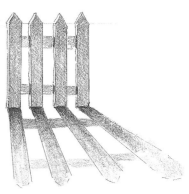

KNOW YOUR ANGLES
The fence at the top indicates sunlight because the parallel shadows had to be made by a very distant light source. The fence at the bottom, however, indicates a probable streetlight because the varied angles of the shadows would only be caused by a nearby source of light.

SHADOWS AROUND CURVES

The shape of the cast shadow created by this walkway is modified by the round structure of the lighthouse, so that the darkest portion is close under the walkway and gets lighter as it goes both ways around the wall. Below that, the vertical area facing the sun is the lightest, and the juncture of these two areas is well defined. As the curvature of the structure increases, the light plane becomes darker to the point of the projection edge, where it then grows lighter toward the shadow side of the lighthouse.

Drawing With Negative Values

Negative drawings are duplications of images made by reversing the tonal values. The lighter a value is in your original, the darker it will be in your negative drawing and vice versa, resulting in an image that looks much like a photographic negative. There are three good reasons to try it: First, negative drawing helps you focus your attention on the relative contrasts of light and dark rather than on the identity of the object you're drawing. Second, negative drawing helps you develop your innate judgment of value contrast. Once you teach yourself to draw negative images, you'll find you can shade positive images with much greater ease. The third reason for negative drawing is that it's good training for the right side of the brain. The left side doesn't like negative images, thus ensuring that they'll be processed on the right, and this helps you to perceive value relationships in the way you need to in order to become the best artist you can be.

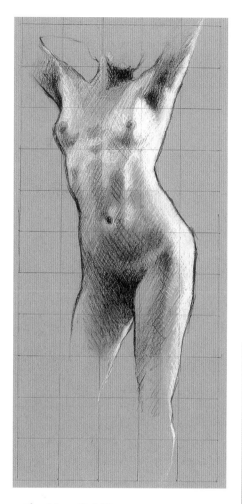

1 Use Gridlines
Lay gridlines over a completed drawing or photograph.

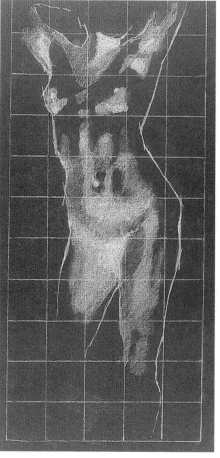

2 Copy the Image Using Reverse Values
Use a white charcoal pencil to outline the torso and the dark areas of the original. Continue to use dark values where you see light and light values where you see dark.

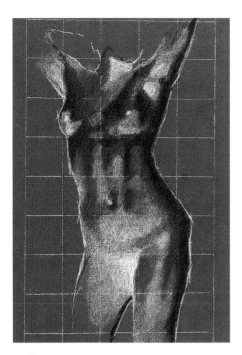

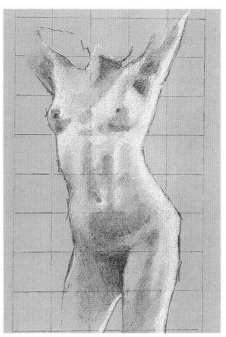

- The imagery for this exercise should be relatively simple. If your drawing or photograph is too detailed, or has a busy and cluttered background, your task will be much more difficult.
- For accuracy, use the grid system to copy the image. (Divide the picture into small sections and transfer their contents one at a time.) This makes correct placement and proportions much easier.
- Remember that a photocopier can't discern contrast as accurately as the eye can, and take this into account when working with photocopies—especially when comparing them to your originals to check your work (see step 4).

3 Complete the Transfer of Negative Values

Build up the light areas of the original with black pencil. To keep the range consistent, regularly refer back to the original.

4 Check Your Drawing

With a laser copier, make a negative image of the second drawing. This will convert your negative drawing back into a positive drawing. If you've done well, the copy will resemble the original.

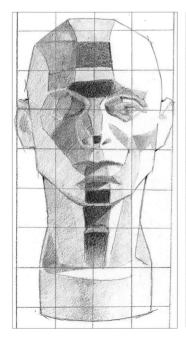

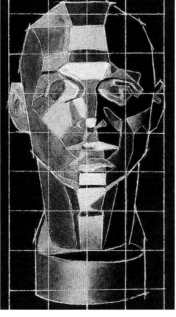

GET BASIC
Build your skills easily by using a simple anatomical reference, such as a doll's head. Here I made an original sketch in pencil on white illustration board, then made the negative drawing with white pencil on a black board.

ADD ENERGY WITH ACCENTS

Butch Krieger

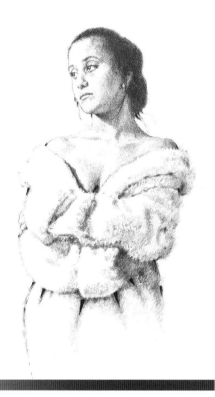

When you're doing field sketches, it's critical that you get your ideas down as quickly as possible. After all, you may never see your subject in exactly the same way again. This challenge came home to me in a big way when I worked as a courtroom illustrator for television news networks. In those days, I frequently had to produce depictions of fleeting images. I always began with quick, freewheeling line sketches using black pencil and a very light touch. Then I would develop the images with colored pencil. Once that was done, however, the original outlines looked faint and indistinct. Yet because of deadlines, I didn't have time to go back over the entire sketch and painstakingly darken the full length of each line.

Eventually, I discovered that I only needed to darken key segments of the more essential lines. I named these dark accent marks "power points" because they add energy and strength in key areas. I usually add them as short, dart-like lines. Often—but not always—you'll find that power points occur where the end of one line intersects the side of another line. As I experimented further, I discovered that power points can also be used to balance the overall composition of a drawing. Here's a look at how you can use them to create stronger, more exciting drawings.

ADD BODY TO YOUR LINES
Power points—small, dart-like accent marks like those in red above—are an effective tool in any kind of drawing. For example, in this pre-study for an oil painting, I used them to add a little body to the lines so I could retain the overall soft feeling I was after without having the drawing look flat or weak. Although there are power points throughout this piece, they're particularly visible where the lines of the hair intersect the lines of the face.

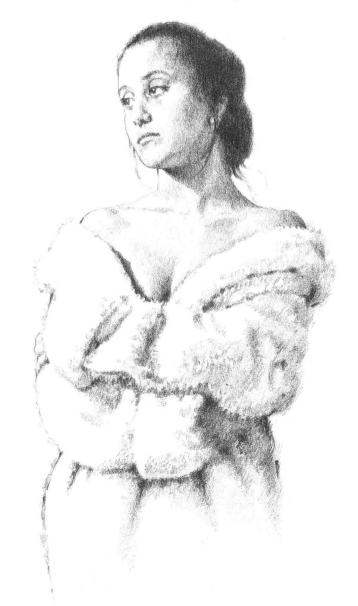

Power in the Studio

The advantages of power points aren't limited to extemporaneous sketching. They can be decisive compositional and aesthetic devices, as well. The careful placement of the feathered power points in the drawing of the woman with the robe on the previous page allowed me to preserve the soft, fluffy contours of the robe's fur-like texture without sacrificing the underlying structural formation of the robe itself. Power points were also used to help create the illusion of depth. Note, for instance, the contour of the woman's right shoulder where it meets the garment. Not only does this power point accentuate the graceful curve of the shoulder line, but it also moves the shoulder form back into the embrace of the robe. You can see a more subtle accent mark in the delicate wisp of hair that emerges from behind the model's face on her right side.

Add Excitement

The power-point principle works just as well in the rendering of a quaint, Victorian home, a majestic oak tree, a panoramic seascape or any other subject you can imagine as it does in portraits. Try capturing images as quickly as possible using light lines. Then begin adding power points. When getting started, you may find it helpful to refer to the images in this article. With concentrated effort, you'll find that power points allow you to produce a finished drawing in a shorter amount of time and help you create stronger, more unified compositions as well.

MAKE A STRONG POINT

This graduation speaker gave a very short talk—he actually stood at the podium barely long enough for me to get a good graphite line sketch with just a touch of shading. I added the power points after he'd concluded his speech. You'll find them around his face (his cap and collar), in his long, flowing robe and in the lectern. These power points give the sketch a much more satisfying, complete look.

Compositionally, I used power points to create a sense of balance by distributing them throughout the picture. The power points in the lower part of the sketch keep it from looking too top heavy. At the same time, they allowed me to suggest the lower area without developing too much detail, which would have competed with the upper area. Thus I could focus the viewer's attention on the most important element: the speaker's face. Finally, the power points visually stabilize the otherwise loose, freewheeling sketch and give the drawing an overall sense of unity.

ESTABLISH THE BASICS

I sketched this woman at a banquet. I knew she wouldn't be holding this pose long, so I had to work fast. In the first stage of the drawing, my lines were tentative and reserved (top). Several days later, I returned to this drawing and added the power points (center). I used these economical marks to accent the key points in the composition. Notice that the power point on the hat brim (where it meets the edge of the forehead) visually pushes the rim back into the shallow space beyond her head. If you look carefully, you can see how these marks strengthened the finished piece (bottom).

DEFINE YOUR EDGES FOR REALISM

Bill Tilton

The way you treat your edges has a lot of influence over your artwork. From the hardest to the softest, there's a wide variety of possibilities in how your edges are rendered, and applying the whole range effectively can make the difference between an adequate work and a truly impressive one. So let's take a look at how to use these fundamental tools to give your drawings the look of real life.

The Hard Edge

Most edges in good works of art aren't overtly evident unless you make an effort to see them. But the hardest edges are usually the most visible. Think of the paintings of Alex Katz and Roy Lichtenstein, for example, which usually feature large, flat areas with stylized figures. Or, more simply, think of the average comic strip. Most of the shapes are defined by sharp outlines. Perspective may be perceptible in these works, but the depth of field that most representational artists strive for isn't an apparent goal.

So does that mean that realist artists should abandon hard edges altogether? Not at all. Often the forms of hard objects like boards and stones, and smooth objects like apples and eggs, are best rendered with hard edges. The same is true of human limbs where their bony structure is evident, such as bent elbows. In general, hard edges control and compartmentalize your view of a picture, and they usually attract the viewer's attention, so they're particularly useful around your center of interest.

Keep in mind, however, that hard edges don't require sharp lines, as the drawing of the lightbulb at left illustrates. Nature has very few distinct lines. A carefully measured relationship between lights and darks can make a more convincing hard edge than a drawn line, no matter what the drawing tool.

The Soft Edge

In works that strive for the illusion of depth, soft edges are one of the artist's best tools. Their vagueness can create the impression that an object is textured and receding into the distance, and that there's literally something on the other side. Objects in the far background of a picture, such as buildings, trees and mountains, call for softer edges. So do receding shadows.

While clearly drawn lines are often less preferable for creating a hard edge than techniques like contrasting values, textural definitions and the placement of forms, there may be times when a hard edge simply calls for a hard line. Soft edges, in contrast, are generally indistinct or vague, so sharp lines should be avoided. That's one of the best ways to convey realistic texture.

The Lost Edge

One of the most important methods of giving your work dimension is the use of lost edges. They're not readily apparent, but their effectiveness is. The edges of the objects

THE ABSENCE OF LINES
I created this drawing of a lightbulb (based on a 1965 drawing by Walter Murch) without a single outline. All the edges are made apparent simply by the value relationships, which produce a soft, spacious, three-dimensional appearance that sharp lines wouldn't convey.

closest to the viewer are clearly defined, but farther back they become less so, to the point where some edges aren't visible at all as the contrast between the object and its surroundings disappears. The result is an edge appearing to trail off into the distance or, when in the foreground, being overpowered by more prominent and sharply defined foreground elements.

Creating edges can be a tricky task in black and white, which often requires strong presentation of values, but with dry media, such as graphite and charcoal, a kneaded eraser or chamois skin is great for softening edges or removing them entirely. In color, your combined color and value choices can define your edges nicely, and scumbling with paint is a great way to soften them.

There are a few guidelines for the use of edges in general. First, the look of an edge varies with the medium and the tool you're using, but the tools and the media aren't made specifically for a certain type of edge. For example, edges created with a spatula are distinctly different from those created with a sable brush, yet an adept artist can create a good range of hard and soft edges with either instrument. Second, use your edges in coordination with other elements of the painting. Soft edges, for instance, tend to recede, so they can be combined with cool colors to make an object appear far away. Hard edges, which tend to jump out at the viewer, can be very effective in combination with warm colors.

Finally, remember that your use of edges shouldn't be based on any formulas or rules but on your own observations and senses. Most works will combine a variety of the three types of edges, so don't become too reliant on whichever one you do best. No matter what you're drawing or painting, take some time to concentrate on edges and how they interrelate, and you'll see what great results they can give you.

CREATING VOLUME

The petal that appears in the center of the flower at left was naturally split and upturned, so it gave me the opportunity to draw the underside in shade. The dark values give that petal a hard edge against the well-lit surrounding area, and the contrast with the indistinct edges of the rest of the flower makes that petal seem to protrude.

In the cluster of flowers at the right, much of the three-dimensionality comes from the lost edges that either disappear in the shadows and light or are overwhelmed by the more distinct edges.

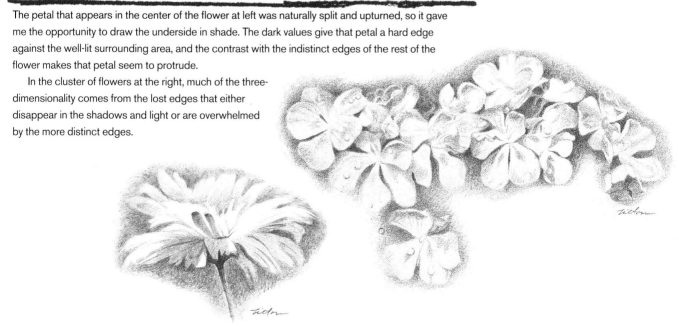

MEASURE YOUR SUBJECTS FOR ACCURACY

Carrie Stuart Parks

Any object in front of you is measurable. Most people have been taught to measure an object by comparing it to something they know. Traditionally, you may compare something to a specific measurement, such as a ruler. There is an expression "bigger than a bread box"—though most young people today have never seen a bread box. This is a comparison. Everything in front of you can be compared. An object is either the same size as, larger than or smaller than something else.

Compare Distances

Using a map as an example, you check the distance from one point to the next by comparing it to the map scale. You don't use the scale to measure another map or the length of a baseball field—only the contents of this particular map.

You can measure a variety of objects using other forms of measurement, such as a gallon or a meterstick. Artists also measure objects. The difference is that they measure an object by comparing it to itself.

Find Your Baselines

A baseline is a comparison system. For example, when compared in a range of Chihuahuas to Great Danes, a "big" dog is a German shepherd. A German shepherd, however, is not all that big when compared to an elephant. Size is relative to what is being compared. When you use this system in art, you compare the baseline in the image in front of you to something else in the same image. For example, you may wish to compare an object's length to its width. Because you'll be drawing this object, you also have a straight line that you can use as a baseline in your drawing.

Baselines in Photographs

The easiest way to measure objects with a baseline is to use photographs. Photos don't move, are already in two dimensions and are easy to refer to. To do this simple exercise, you will need a pencil, an eraser, a sketch pad, a scrap of paper and a large, easy-to-see photograph.

CHECK YOUR PROPORTIONS

Proportions are like maps—they provide an overall view of where things are and how they fit into the whole picture. Most people have a pretty good idea where the facial features are located. The eyes are above the nose and the nose is above the mouth and so forth. The first drawing concept is how to locate various items we wish to draw with more exactness.

Some books written about faces are not always correct on the placement of the facial features. They may generalize or use some kind of Greek idealized face with a long, thin nose. It's important to look at whatever you're drawing as you contine this learning process. It's hard to measure, line up and view images that exist only in your imagination: That's why drawing from photographs can be such a help in learning.

Proportions are a comparison, a relationship between objects dealing with size, volume or degree. You may be able to draw the greatest eyes in the world, but if they're in the wrong place, the drawing will be off. Proportion is the relationship of different elements in a work of art.

Establishing Baselines in a Photograph

1 Choose a Baseline

Select an object in the photograph that is measurable with a straight line, such as the width of the eye from side to side. Your baseline should be easy to see and a fairly short line (that's why you use a small object like the eye). Take a scrap of paper and measure that width.

2 Transfer the Baseline Width to Your Paper

Place the same length of line on your paper. The line you have marked on your paper is your baseline. With this one single, simple line, you can proportion and render every other facial feature.

3 Compare and Measure the Other Features

Compare the proportion of one feature to the baseline. Using the same scrap of paper, you can now measure every other part of the face by comparing it to the width of the eye.

4 Place the Correct Measurements

Mark each measurement on your paper.

Establishing Baselines on a Three-Dimensional Subject

1 Select the Baseline on the Subject

Select a portion of the face or body to use as your baseline. The baseline should be a fairly small horizontal or vertical line. Remember that a baseline is something you will compare everything else to in your drawing.

2 Measure the Baseline

Extend your arm straight out in front of you, holding the pencil as illustrated here. Close one eye and use the tip of the pencil to mark the start of the head. Use your thumb to mark the end of the head. This measurement is your baseline.

3 Compare the Baseline Measurement to the Figure

Using the measurement of the tip of the pencil to your thumb, compare the figure to establish if something is the same size, larger than or smaller than that measurement. Using this system, you can compare the height of the head to all other parts of the body. Whatever measurement you choose to make the head on your paper, you will compare the rest of the body to that starting point.

CHECK FOR ACCURACY

Always check your work for accuracy. As you work, your mind is processing and placing your drawings into patterns of perception. After a fairly short amount of time, you will no longer really see your work. You need ways to break that pattern of perception.

Carrie Stuart Parks

Inverting

Inverting your art simply means to turn it upside down so it looks different. You may see any errors or problems more clearly.

View it From a Distance

Changing the distance alters the way the art looks. Walk away, walk back, wander around the room and sneak peeks at the painting from different angles—you just might find a way to make it a stronger piece.

Walk Away

Because your mind has placed the drawing into a pattern, if you walk away from that work, you will see it differently when you return. Build in breaks away from your work. Caution: When you first return to your drawing, immediately write down the corrections you see or you will forget them. Trust me.

Utilize Tools

A common tool is a ruler for checking angles. Another tool is a piece of red film held in front of your eyes: It will block the art into values and will help you make those corrections. Other tools will show you shading, angles and perspective. There are tools that will help you see better. Tools are physical aids to make you a better artist.

Study the Reverse

Holding art up to a mirror is a long-standing artistic technique. The reverse of the art shows some problems more clearly.

Ask for Input

Sometimes you can't see it, but someone else can. Ask your friends and family members what they think of the work—and ask someone you trust to be frank.

Get a Critique

Critiques are useful for getting outside input on your work. They help you see the art with fresh eyes.

Combine Several Techniques

Of course, a combination of the accuracy techniques is an artist's best bet. Try a few and see if you can't find some small glitch that, with a little correction, can make your work extraordinary.

DIVIDE SPACE IN YOUR PAINTING

Jerry McClish

The size of your picture and the placement of your center of interest are decisions that shouldn't be made at random. But how do you know what the best choices are? The answer is simple: Do what has historically proven effective, and that's where the golden mean and the Rabatman come in. They'll help you get the most visually pleasing division of space in your painting, and that will set you up for a positive reaction from your viewers before you even begin to show off your other talents.

The Golden Mean

A formula used by the ancient Egyptians and Greeks and still employed today, especially in architecture, the golden mean states that the best division of a line makes the ratio of the shorter part to the longer part equal to the ratio of the longer part to the whole line. The same is true for area.

Mathematically, this means that the smaller portion is .618 times the larger, which results in the larger portion being .618 times the entire line or area. This ratio is manifested in the natural growth of seedpods, sunflowers, seashell spirals, pinecones and even cells, and it's also the constant factor in several geometrical progressions.

What does that mean for you as an artist? First, with the method described here, you can use the golden mean to determine the size of your surface so that the relationship of length to width is .618-to-1 (or vice versa). You can also use it to find the possible focal points for the picture, which would divide the space into the same proportions. And, more easily, once you're familiar with how the golden mean works it can become second nature, and you can approximate the measurements without getting out the ruler and compass.

The only drawback of this method is that the size of the picture created by using the golden mean often doesn't match the commonly available papers and canvases.

THE GOLDEN TOUCH

Here's the precise way to create a pictorial space using the golden mean: Start with a square, then place the center pin of a compass at the midpoint of the bottom edge (B). Swing an arc out from an upper corner and extend the bottom edge of the square out to meet the arc (see segment C), then complete the rectangle with B+C as the base. This method has created an important relationship: The ratio of the height of the rectangle to its width is the same as the ratio of the width to both put together. Mathematically, A is the same proportion (.618) of B+C as B+C is of A+B+C.

The golden mean can also guide you to the best placement of your focal point, which would lie a bit more than a third of the distance away from the two nearest sides (see the example at left), thereby dividing the space into the same proportions. In the diagram above, the ratio of C to B is the same as the ratios already mentioned, so line D is a natural place of focus.

Why does this strategy work? We don't know for sure, but plenty of experience and research has shown it to be visually satisfying. And once you become familiar with it you won't have to measure or calculate—just approximate the proportions and you'll have a picture that falls right into place.

The Rabatman

There are also a couple of quicker ways to benefit from some of the same principles used for the golden mean. The Rabatman is a method that gives you a division of space much closer to the sizes of paper we're accustomed to, but it does not involve a repetitive ratio or constant. It's similar to the golden mean but uses the diagonal of a square as a radius to create a rectangle that turns out a bit shorter. Also, an easy method for locating a center of interest in any picture space is to simply create a diagonal across the picture, then divide it into thirds to find the two points along that diagonal that are comfortable focal points.

Each artistic composition can seem to make its own demands, however, so while these methods give us safe and reliable guidelines, take into account the uniqueness of your picture. Multiple objects, strange shapes and repetitive patterns can force you to break the rules. But always remember that many centuries of art and architecture have taught us a lot about how we see, and a little bit of good engineering can be all you need to take advantage of that.

THE ALTERNATIVES

The Rabatman (below left) creates a picture by a method similar to the golden mean, except that the compass pin is placed at a corner of the square and the arc is drawn from the opposite corner down to the base. Also, a simple method for finding focal points (below right) is to draw a diagonal across your picture and mark the points that divide it into thirds.

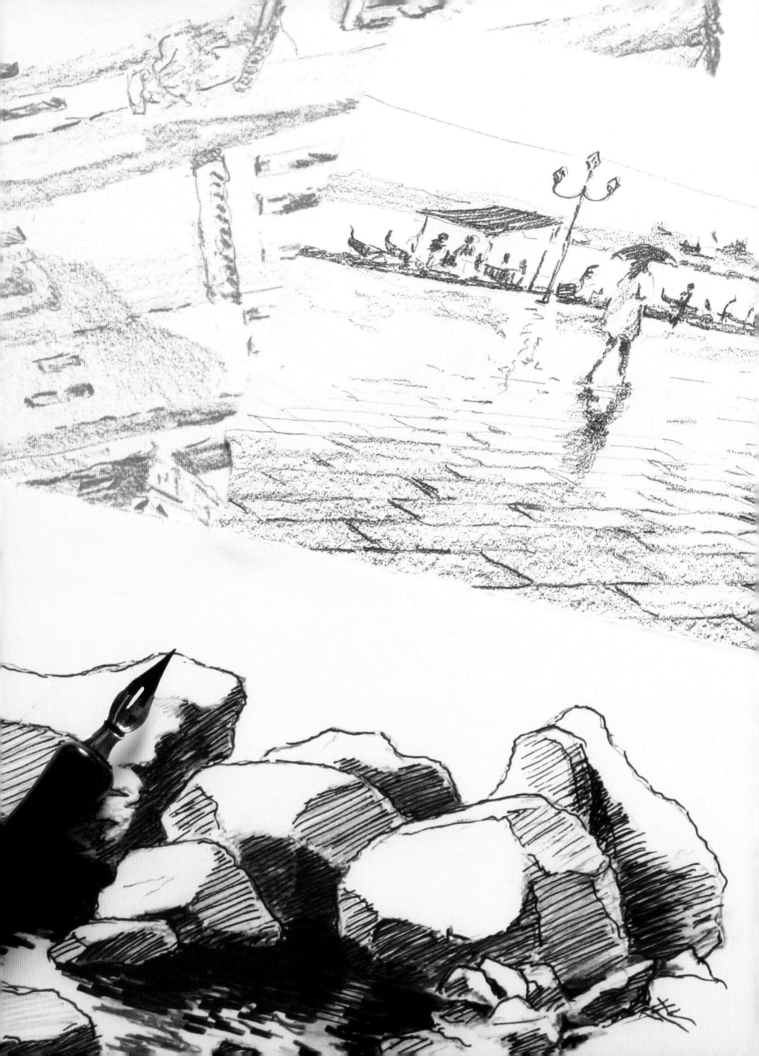

Landscapes:
The World Around Us

Is there anything more inspiring than the wonders of nature that surround us? Just as it was for Monet, van Gogh and so many artists before us, merely opening your eyes at the start of the day is an inspiration to put pencil to paper.

Let these modern drawing masters guide you through exciting ways of capturing the beauty that surrounds you. Learn new ways of interpreting and depicting the mountains, trees, rivers and oceans that will keep bringing you back to the drawing board again and again.

ESTABLISH A STRONG PICTURE FRAME

Jerry McClish

Choosing a subject to paint is probably the first step in the artistic process for most of us, but the next step is a crucial one that artists sometimes overlook. It's the decision of how to frame your subject, and it has nothing to do with the frame you'll put around the picture when you're finished. I mean framing in terms of what goes in and what gets left out of the picture and where eye level lies. These are composition decisions that have a big impact on the quality of your art, no matter how good your rendering skills are.

Some experienced representational artists can look at a scene, evaluate it and immediately start to assemble a picture. But most of us can benefit by considering a few different options and making some adjustments to the scene. Unless you've found the perfect subject, a view will probably lack something that could make it more interesting, be too busy or need some rearranging. Here are a few ways to get started on the right track.

Set Your Borders

A good first step is recognizing that you have plenty of flexibility in choosing where to place the borders of your picture, and therefore in choosing what goes in or out. A good tool to keep handy is a pair of L-shaped pieces of mat board, which you can use as an adjustable viewing mat to look through at the scene. Hold the pieces together to find what proportion is best suited to your subject, and change your viewing borders by moving the mat back and forth to determine how much of the scene is to appear in the final picture and how large the subject will appear to be. The mat must be held perpendicular to your line of sight.

Don't be bound by reality, however. The subject you want may be in a good setting but surrounded by too many other elements, and the viewing mat can help you see this. Omit or rearrange objects if necessary for a better composition. Sometimes simplifying the scene can be a big improvement.

Locate Your Eye Level

Think carefully about where the horizon will appear in your picture because it has a big impact on the viewer's response. We instinctively sense eye level to be near the middle of the picture frame, where it would naturally be for a person looking straight ahead. But when you place the horizon right across the center of your picture, it tends to create a surprisingly static scene where the viewer doesn't know whether to focus on the top or the bottom half. This is usually where you'll see the horizon in a simple photograph, and it's often a tip-off to experienced competition judges that artwork was copied from a photo.

When eye level is placed near the top of the picture, emphasis falls on the upper portion. This division of space complicates your choice of what to place in the lower,

WORK WITH THE ELEMENTS
These two boatyard scenes show how the choice of composition can change a picture. On top is a drawing of how the scene actually looked, encompassing everything in sight, while in the second sketch I pulled in the borders, removed a few houses and a couple of boats, and added a few workmen. The result is a composition that's much less cluttered and has a better sense of focus.

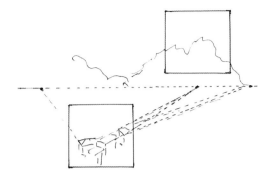

larger area; it needs to adequately complete your composition without being too interesting or overly detailed. More common is the low horizon, which also stresses the upper portion of the picture and may focus on an expanse of sky or some structures reaching upward.

If you're in the mood for something a little different, don't forget that you can go to extremes by raising or lowering the picture frame beyond the horizon altogether, as shown above. As a matter of perspective, the vanishing points for your subjects will still be located on this horizon, or eye level, now above or below the picture. This approach gives viewers the unusual—and potentially exciting—sensation of looking beyond normal eye level.

Direct the Light

Very early in your drawing stage, be sure to establish the direction of light, and be sure that its angle agrees with your other compositional decisions. Although it may seem correct, the light you see in a scene may not be right for your composition. You can have the light coming from any direction if it improves the picture. Just make sure the direction is kept constant. This consistency shows up in the highlights of objects, it establishes the light and dark planes and it dictates the direction of cast shadows.

If you can make all these decisions up front and get them to work together, you'll have the basis for a good picture. With that foundation, you can set your other drawing and painting skills loose with the security of knowing you've chosen the picture frame that your work deserves.

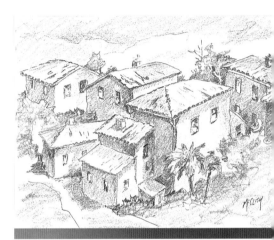

GOING TO EXTREMES
When you eliminate the horizon by raising or lowering the picture frame beyond it, as I did in this drawing of an Italian village, you can give viewers a surprising new perspective by displacing their eye level. But you must remember that the vanishing points of your objects will still be at the horizon.

EXPERIMENT WITH BORDERS

With a pair of L-shaped pieces of mat board, you can view a scene within any borders you like. But the placement of your horizon is crucial because it typically determines eye level. When it's in the middle (A) it creates equal upper and lower parts that can be rigid and confusing, and when it's high in the picture (C) it tends to de-emphasize the large lower space. Most artists choose the low horizon (B), creating a more natural view.

eye level ---- A ---- B ---- C ----

GIVE YOUR SCENES A WORLD OF DEPTH

Jerry McClish

Representational painters constantly have to deal with the problem of conjuring up the third dimension on a two-dimensional surface. Portraying depth is crucial to making a realistic picture that will capture the imagination of viewers, but depth on a flat surface is just an illusion, and to create this illusion you must know how to draw. More specifically, two important aspects of creating depth are proportion and perspective, so here are a few strategies for taking control of these factors and giving your scenes plenty of room to explore.

Create Proper Relative Size

Creation of space in a picture depends on many things, but perhaps the most important is the relative sizes of the objects in the picture. As you know, objects appear smaller as they recede into the distance. But that's not all there is to it.

In a picture, the difference in size between objects creates the distance between them. The illustration on the next page, which contrasts two sketches of vastly different relative sizes between the same subjects, is a good example of this principle.

You can place a person in front of a mountain, but the illusion of depth that you give the scene can vary by as much as miles, even before you add anything more to the picture.

Don't forget, however, that the more space you create, the more you have to fill. In this simple example, the act of placing the person and the mountain miles apart leaves the picture with miles of emptiness, so be sure to use the territory in a way that suits your subject. Consider adding elements to the picture that will enhance the presence of this space. Repeated objects—a house or a tree, for instance—that retreat into the distance and appear gradually smaller are an especially effective device.

When designing a composition, the first object you draw is extremely useful because it defines the scale for everything else. Once that object is drawn, the amount of depth you want in the picture will determine the size of all the other objects. If it's a human figure, for example, any houses or buildings at the same level of depth in the picture should permit the person to fit through the doorway. The degree to which these sizes differ will determine the perceived distance between the objects in the third dimension. The figure of a person serves as a good example for this technique, but you can use any shape (a tree, a chair, etc.) in a similar manner to establish the proportions of all your other elements.

When distances between objects are small enough that they don't justify noticeable differences in size, merely overlapping the objects can create space between them. In addition, depending on the source of light, shadows are a great indicator of the third dimension. For instance, the shadow side of a building next to the sunlit side shows a change in plane that provides a great sense of depth.

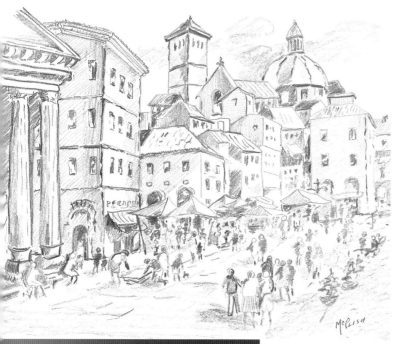

ENTERING THE SCENE
This pencil sketch of the Italian hill town of Assisi is really a jumble of sizes, shapes, curves and angles. Because of the varied terrain, I had to guess at the perspective of some of the buildings. But this sense of shift, as portrayed in the clustered buildings and the many people in the street, gives the sketch an inviting sense of physical space.

Make the Space Convincing

Establishing proportional size is a vital part of creating depth in your work, but the more space you create, the more you have to fill. Once you've opened up the extra dimension, make the space convincing by giving the viewer a firm and reliable sense of perspective. It's generally not hard to make sure that receding parallel lines meet at an imaginary vanishing point on the horizon.

Correct perspective is a little more difficult for objects that aren't composed of straight perspective lines, yet this principle is still very important for the illusion of realistic space.

These objects have what I call hidden perspective, where the lines of perspective don't appear in the final drawing. Take as a subject a forest composed of many different kinds of trees, for instance. If the trees are varying in size, the terrain is varied and the deepest parts of the forest are drawn mostly as undefined masses (as is often the case), you'll have to imply a sense of perspective instead of defining it. Fortunately, these very complications can make your job easier. Undulating planes are a great way to add depth naturally, serving a purpose similar to that of multiple stage sets as they recede. By obscuring the land behind them, these small elevations give you a bit more flexibility in establishing perspective than flat ground does. Also, the density of your arrangements allows you to make the best use of overlapping and changes in size. Gradually giving distant trees less definition and contrast is a way of putting space in between them and the viewer.

You're entitled to take a few liberties with perspective, too. The more practice you get as an artist, the easier these depth-producing techniques become. Experience also gives you a better appreciation for how important the feeling of depth is to a realistic painting, as much for still lifes and portraits as for landscapes. Opening up that third dimension is a way of inviting the viewer to step into the world of the artwork, and that makes any piece of art successful.

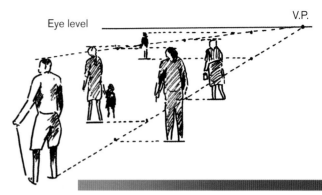

Eye level V.P.

RECEDING FIGURES

To make figures recede into the distance, find a vanishing point by drawing lines from the foot and the head of the first prominent figure that meet in the distance at eye level in the picture. Any figure within those lines (with adjustments for an individual's height) will be in perspective, and figures off to the side can be measured by connecting them horizontally to your original lines. Doing this correctly is important to making the space between the figures appear convincing.

SIZE DETERMINES SPACE

As these illustrations show, the relative size of your subjects determines the space in your picture. In the scene at left, there's an appreciable distance between the viewer and the figure and between the figure and the mountains. In the scene on the right, the distance between the figure and the viewer is reduced. But the overall depth of the picture seems much greater because such a vast space is created between the figure and the mountains.

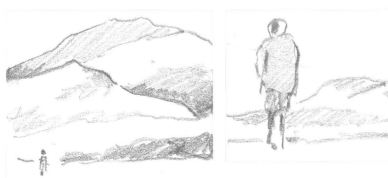

61

USE PERSPECTIVE TO CREATE REALISM

Jerry McClish

Accurate drawing is essential for strong representational art. And if you're looking for accuracy, you can't avoid learning the basics of perspective. The good news is that, in spite of its often daunting reputation, perspective is fairly simple if you view it logically and with an open mind.

There are lots of ways to approach perspective, so for the sake of keeping the subject manageable, I'm going to limit myself to one of the common problems I see in my workshops: using perspective to make tiles or paving stones appear to lie flat. This topic may seem narrow, but the strategies I'm using aren't. They can help give you a better overall understanding of perspective and thus provide a springboard for creating stronger, more realistic drawings. As you study and recreate the examples presented here, you'll also find it helpful to remember this key bit of advice: Think simple and it will be simple.

Capture the Right Placement

Drawing tiles or paving stones in perspective is simply a matter of capturing the correct placement and proportion of each square or rectangle. Let's start by tackling tiles arranged at diagonals to our line of vision. First, draw a single tile and use it to establish two vanishing points—one on the left and one on the right. For instance, assume that you're drawing a floor paved with square tiles. Looking at the floor from above, the usual two vanishing points are quite evident. The third, not-so-evident vanishing point will be located at eye level, somewhere between the two established points.

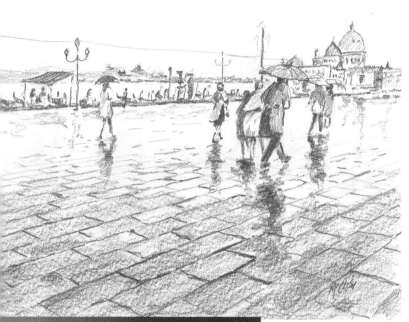

PERSPECTIVE ALWAYS HELPS
No matter what you draw, an understanding of perspective can help you draw it better. This sketch of St. Mark's Square, Venice (graphite, 9 ¾" x 12 ¾" [25cm x 32cm]) is an example of how to keep oblong paving stones in perspective and lying flat on the ground. The left and right vanishing points lie somewhere outside the picture plane. The third, phantom vanishing point is located a little to the left of center on the horizon line.

Once that third vanishing point is in place, you can use it to establish the proper placement and proportions of the remaining tiles. To do this, start with the tiles in the first row, using the lines receding to the first and second vanishing points as guides. As you add each new square, draw a line through its opposite corners, as you did with your first square. This approach works because any two points can be used to form a line in perspective. If the new square is the right size, this line will automatically recede to the third vanishing point. If it doesn't, simply adjust the size of the square until it's right.

When the first line of tiles is in place, move to the second row. It gets easier here—the lines to the third vanishing point are already in place, so it's just a matter of drawing the new squares so the lines pass through opposite corners.

You'll find that this approach works—with a slight modification—even if the tiles are in a staggered, or running-bond, configuration. When that's the case, simply draw your perspective lines through the corners of alternating pavers to find the third vanishing point. (To familiarize yourself with the look of staggered, oblong tiles, you may want to first establish a floor made up of small square tiles, then move left to right across the drawing erasing every other line.)

Make Realistic Space

If you're viewing a floor with rows of tiles marching straight across your picture plane at right angles to your eyes, it may initially seem that a third vanishing point won't work. But while the drawing is a little more complicated, we're still dealing with simple perspective. For example, in the sketch showing the overhead view of the floor, the right and left vanishing points seem infinite. In such extreme cases, merely draw the tiles as parallel rows of tiles across the picture plane.

In all but an overhead view, however, the third vanishing point always falls somewhere on the eye-level line. As you look at this drawing, notice that I also added a fourth and fifth vanishing point to establish the correct proportions for the receding tiles. To do this, I divided the picture plane in half based on the perspective lines of the middle tile. Then I created vanishing points for each half of the drawing.

Control Your Perspective

Many artists gloss over basic perspective problems, probably in the hope that they'll get lost in the overall composition. Of course, that doesn't work. These pesky receding lines are a necessary part of any representational drawing. So don't ignore perspective. Meet it head-on. You'll soon find it's not nearly as fearsome as its reputation, and in the process, you'll elevate your art to greater levels of accuracy.

IDENTIFY YOUR VANISHING POINTS

When drawing square tiles or paving stones in perspective, begin by identifying the vanishing points on the right and left, as seen in these two diagrams. If the tiles aren't parallel to your line of vision, you can ensure proper proportion and placement of the tiles by finding the elusive third vanishing point. To do this, draw lines through the corners of the blocks. The illustration below right offers an overhead look at how this works, while the example on the left offers a more typical view with the lines receding toward the vanishing points.

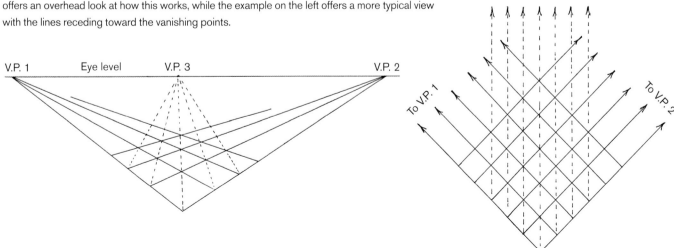

DIVIDE THE DRAWING TO FIND PERSPECTIVE

Tiles arranged at a right angle to your line of vision present a special challenge. The right and left vanishing points fall well outside the picture plane, but the third vanishing point is easy to find on the horizon line. However, the problem of placement and proportion for the remaining blocks is still unsolved. To make sure that all of the blocks are right, you'll need to divide the picture plane in half and draw perspective lines through the corners of the blocks in each half to identify the fourth and fifth vanishing points, as shown in these diagrams.

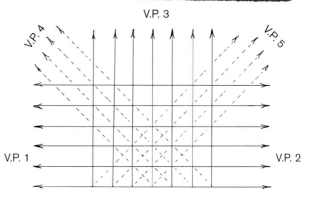

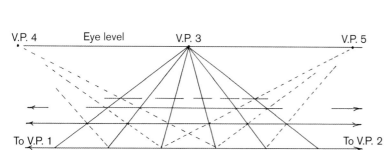

MASTER A STAGGER

This pair of drawings demonstrates how to identify the third vanishing point when dealing with oblong tiles in a staggered configuration. Once again, notice that these tiles aren't parallel to your line of vision. Begin by finding the vanishing points on the right and left. Then establish the stagger and locate the third vanishing point by drawing perspective lines that pass through the corners of each tile.

ADD VARIETY TO YOUR TREES

Trees are one of the most popular drawing subjects available, and it's not hard to see why. They can suggest all kinds of ideas and designs that you can incorporate into your work, and you don't need to be an expert botanist to seize these opportunities. Some basic drawing skills and a little study of how trees are constructed are all you need to successfully populate your landscapes.

To understand trees and be able to render them accurately, we must realize that every tree is a living thing with characteristics that develop over time. One reason for the popularity of trees is that they readily lend themselves to telling a visual story by showing the changing seasons—from the bare limbs of winter to the buds and flowers of spring to the lush foliage of summer to the beautiful colors of autumn. With a good appreciation of this evolution, all you'll need to start drawing is a pencil, a sketchbook and a favorite tree.

Study Tree Growth

When studying trees for my drawings, I find it difficult not to marvel at what a wonderful feat of engineering I'm looking at. Some species can reach enormous heights, supporting tremendous weight (including a small world of wildlife and plant life) while still swaying gracefully in the breeze. Because trees grow upward, a handy way to view them is like a telescope, divided into sections with each section a little bit smaller than the one below and fitting inside it, forming a balanced and tapered shape.

The limbs of a tree follow the same principle of diminishing size. Out of the trunk grows a bough that's smaller in girth, and from the bough grow branches, and from the branches grow twigs. Each is smaller (though not necessarily shorter) than the piece before it, creating a balance that enables the tree to withstand significant punishment from weather and wildlife over time.

To start drawing, try a simple contour drawing of a tree that you'd like to paint. Whether or not you use your drawing as a foundation for later work, this step allows you to concentrate on the tree's outline, and by doing this you'll better understand the shape and form of your subject. Plus, this sort of drawing gives you the opportunity to experiment a bit with the tree's basic structure so that you can see for yourself how a severely unbalanced composition just doesn't occur naturally.

It's important to give the impression that your tree genuinely grows out of the ground, and there's nothing less convincing than a tree that appears to be merely set upon the surface of the earth. Below a tree lies the root system, most of which is underground, but you can usually see where the roots first emerge and gather toward the base of the trunk. Also, if you could go back far enough in time, you'd see that all boughs, branches and twigs began as buds. These buds sprout from twigs, and their placement varies with the species of the tree, but if the perspective of your drawing is close-up a few buds will add a touch of realism.

Stanley Maltzman

A SYMBOL OF LIFE
Trees are nearly ubiquitous in landscape painting, but it's easy to forget that they're living, evolving organisms. This is the reason no two are alike, and you can play up these differences with quirky shapes and irregularities as I did on this sweet cherry tree, using 2B and 4B charcoal pencils.

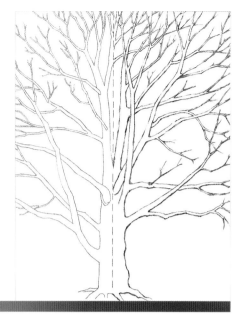

VARIATIONS IN LINE
You can easily add life to your trees by
varying the lines. To show this, I divided
a tree in half with a dotted line in this
contour drawing. The left half, drawn
with an HB graphite pencil, maintains the
same line thickness throughout, and while
it's an interesting composition the constant
line becomes boring. In the right half,
drawn with a 4B pencil, I varied the
thickness by changing the pressure,
creating the appearance of light and
shade with nothing but lines.

See the Whole Forest

When you look at a forest, you typically see trees big and small, wide and thin, coniferous and deciduous. Drawing this mass is not as difficult as it sounds, though, because instead of trying to make an exact copy of every tree, you can view the forest as a pattern of lights and darks.

Begin your group of trees with some rough sketches that identify the major shapes of the composition. Once you've decided which sketch works best, redraw it lightly onto your support, and then build up the drawing by adding shading to create a variety of values. Start with the darkest areas and work toward the lightest, varying the pressure on your pencils and erasing gently if desired. If the spaces between the trees are lighter than the trees themselves, that indicates a shallow forest, while darker spaces between the trees indicate deep woods.

In general, try not to use too many repetitive shapes close together or your forest is liable to appear artificial. Establish a sense of depth (and avoid any potential monotony) by following the rules of perspective, keeping the spacing between the trees random, and perhaps placing some of your trees distinctly in the foreground. If you're using a close perspective, some of your trees may even run off the edges of your paper. If your trees are backlit, allow some of the light to emerge from the trees and even flicker on the ground in front of them. Also, if the trees are your main subject, remember to create a focal point among them for the viewer.

Adding Life

Finally, if you have the opportunity, don't forget to treat yourself to a few of the fun "accessories" that always come with trees. Bark, for instance, can range from long, reedy hickory bark to papery birch bark to the thick patterns of a mature oak. Knotholes of various sizes, lichen and fungus, spiderwebs and insects, birds and their nests, dead leaves—these are just some of the possibilities, and you'll find almost any tree surrounded by a carpet of fallen debris.

You'll never get two trees that are the same, but with a strong set of basic skills you'll be able to draw almost any of them.

FOLIAGE IN STAGES
To draw an entire tree in leaf, start by lightly
sketching the shape, as I did with this
oak in section A. Then begin shading,
indicating your light, middle and dark
values, as in section B. Don't get too dark,
however, until you're certain where you
want them. Last, finish the tree off with
detail, as in section C, by adding light
limbs against the dark limbs, placing darker
branches against the light branches and
making the edges of the foliage irregular
to create the illusion of fullness.

A
B
C

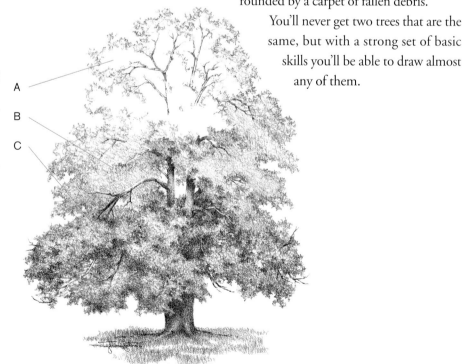

Use Value and Light to Create Forests

USE VALUE

1 Outline Shapes and Add Values

To draw this forest, outline some tree shapes and add a value at the right side that should ultimately appear light.

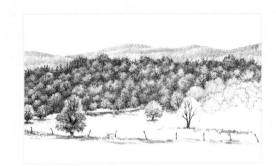

2 Add Tones and Variety

Add a variety of tones around your tree shapes and try to include a little variety.

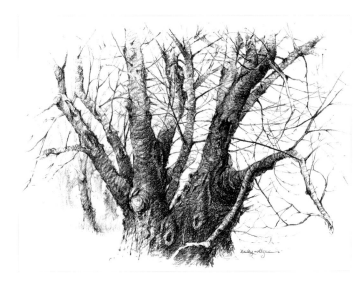

USE LIGHT

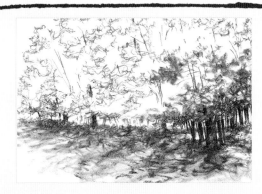

1 Suggest the Foliage

For these backlit woods, begin by suggesting the foliage. Leave some space at the bottom to allow light to shine through the trunks.

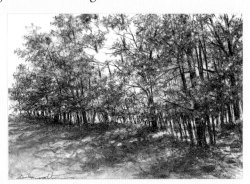

2 Emphasize the Backlighting

Enhance the backlighting by spreading the vine charcoal with a stump, add some detail all around, and pick out highlights with a kneaded eraser.

COMBINING YOUR TALENTS

This old character is a wonderful example of how a single tree can incorporate as many of your favorite elements as you like. Here I drew boughs and branches (some with bark and some without), a double trunk with knotholes where dead boughs have fallen away, and twigs sprouting out all over. Always keep in mind that virtually any tree you design can look realistic—it would be hard to design a tree that nature hasn't already created.

USE ROADS TO ADD REALISM

Jerry McClish

From highways to highland goat paths, roads often play an important role in landscape drawings. Most of us understand how to draw roads that recede across a flat plane toward a single vanishing point somewhere on the horizon line. But in reality, very few roads are perfectly level for any distance. They usually meander up and down, sometimes climbing a steep hill or descending into a deep valley. The challenge then becomes creating roads that follow these ups and downs in a convincing way. Achieving that goal is actually very simple. Here's how it works.

Move Your Vanishing Points

We'll begin our road trip with a single rule: Anytime a plane moves up or down, its vanishing points move with it. So when a road starts up an incline, its vanishing point moves up from the horizon to a point somewhere above eye level. Its exact position is determined by the steepness of the grade.

In "Dealing with Multiple Vanishing Points" on the next page, the road starts out on level terrain, then climbs a hill and disappears over the top. Notice the wide perspective of the road in the foreground. This width may initially seem excessive, but it is true perspective and makes the level portion of the road lie flat. Notice that I marked the point where the plane of the road changes with an abrupt line. Although this change of direction would probably be a gentle curve in real life, this abrupt movement looks correct when viewed in perspective.

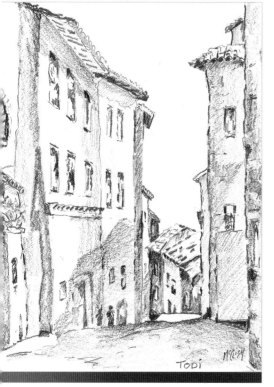

SUGGESTING STEEPNESS

Most of the roads and pathways in landscape drawings aren't flat. This drawing of Todi, Italy (graphite, 10 ¼" x 8 ¼" [26cm x 21cm]), shows a pathway moving down a steep hill. To create it, I first established a high horizon line so that I was slightly looking down at the scene. Then I sketched the flat foreground portion of the path using lines that converge at vanishing point 1 (inset). The portion of the road that turns left down the hill required the addition of a second vanishing point. Notice also how I used the angles of the roofs, windows and doors to accentuate the steepness of the hill.

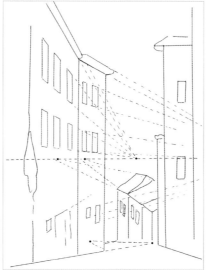

Changing Your Altitude

OK, uphill scenes are relatively easy, but what about roads that go downhill? The best way to solve this problem is to use a high horizon line. A high horizon line means that you're looking down on the scene. As a result, the vanishing point moves lower on the picture plane. In the first drawing to the right, I used the lowered vanishing point to create the illusion that the first section of roadway is going downhill.

The second section of the road is level and moves toward the right. As we saw before, to create the appearance of a level road you must place the vanishing point somewhere on the horizon line. Finally, the third section of the road rises once again to climb the side of a distant mountain. Because this third area is moving to an even higher elevation, its vanishing point is located in the sky area, well above eye level.

In some scenes, a dip may cause the road to disappear as it descends. This is the case at the end of the first section of road in the third example, above. By drawing the hidden section of the road with its phantom vanishing point, I was able to keep the proportional width of the first and third sections correct. Then the plane tilts up as the

road ascends the hill on the far side of the valley. So once again, the vanishing point for this third section is located above eye level.

Dealing With Reality

The examples cited thus far assume that the width of the road is constant. In real life scenes, of course, this may not always be the case. Highways may vary from two lanes to four lanes, or they may be divided. Even small country lanes can vary considerably in width. As you master the techniques presented here, you'll find that you can make allowances for any variations in road width. You can even use buildings along the road to suggest direction shifts in instances where the roadway disappears.

Now it's time to put this information to work for yourself. Try sketching a street and make it go up and down. Enjoy the process. Turn perspective problems into a game. Soon, you'll begin to arrive at all kinds of new creative solutions.

DEALING WITH MULTIPLE VANISHING POINTS

Making roads follow the topography of the landscape usually involves multiple vanishing points. In these three drawings, notice a vanishing point was added to preserve the realism of the road each time the plane of the road moved up or down.

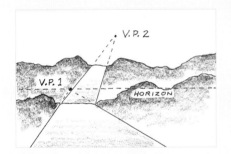 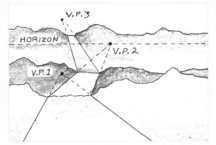 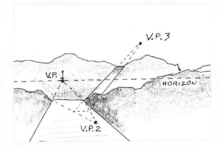

1 Add a second vanishing point in the sky area when a road heads uphill.

2 To accentuate a downward slope, use a higher eye level to bring the vanishing point down below the horizon line.

3 To ensure that the width of the road remains proportionally correct when part of the road drops out of sight, add a phantom vanishing point (V.P. 2).

WINDING INTO THE DISTANCE

These two illustrations demonstrate how you can create a curving road while keeping the width proportionally correct. Start by drawing a straight section of road, marking its width at those points where you plan to add the curves (below, right). Then move those widths to the desired positions and connect them with straight lines, fudging just a little to add short, curved areas (below, left).

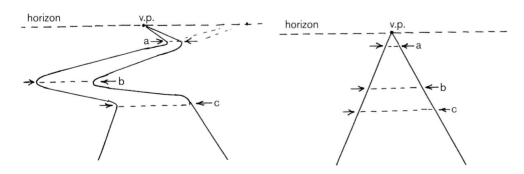

ADD REALISTIC ROCKS TO YOUR LANDSCAPES

John Bickford

Rocks are so abundant in our landscapes that they're often overlooked, both as a design element and as a fascinating drawing subject. Instead of the simple planes artists typically find in a building or a still life object, rocks present us with a wide variety of planes facing many different directions. Sharp edges blend into rounded edges. Combinations of textures and color create surfaces that mask basic shapes. With a little patience and practice, however, you can draw convincing rocks and they can become the most interesting objects in your composition.

Start Simple

Find and draw a single rock, one that fits in the palm of your hand. To concentrate on shapes and avoid getting distracted by texture and details at this stage, paint the rock white with any oil or house paint you have on hand. Then, beneath a single, bright source of light, find the position for the rock that best shows off the light and dark planes. The ability to choose the best point of view for a particular rock is one of the biggest advantages of this exercise.

Make a simple drawing of the major planes that create the basic shape of the rock and try to ignore the in-between planes to avoid complication. Then roughly shade or tone the drawing to give the structure volume. Next make a second drawing, this time adding the secondary planes that provide more character, and when you shade this one be careful not to lose the underlying structure established by your sketch.

Explore Variety

Try this same technique on a variety of other rocks with different shapes, and be sure to follow normal drawing conventions. Dark planes will appear a little darker where they meet a light one, and vice versa. Reflected light helps define the lower edges of dark planes, as do the shadows cast by the rock. For smoothly rounded rocks, shade the side closest to the light, moving across and lightening through the highlight and then gradually darkening into the side facing away from the light.

Drawing rocks in their natural state introduces the complicating factors of texture and color. The banded limestone (bottom right) is a coal-black rock, and my challenge was to differentiate among the tones used for its three sides while still indicating its dark color. The well-worn chunk of pegmatite next to it is a dramatic mixture of light and dark minerals, and the resulting texture dominates the drawing.

Different types of rock tend to crack or break up in different ways. Sedimentary rocks, like the banded limestone, come apart like layer cakes, and sometimes their layers are soft enough to crumble. Most igneous rocks fracture into boxy, sharp-edged shapes that are somewhat easier to draw. Capturing these structural differences in your drawings can do a lot to enliven the composition. Boulders exhibit essentially the same shapes as small rocks, so the transition to a larger scale shouldn't be too difficult.

A NATURAL SUBJECT
Once you've mastered the drawing of individual rocks, you can compose a collection of easily identifiable individuals like these boulders. Often the smaller rocks need only to be rendered with a few key lines and texture suggestions.

DISTINCTIVE FORMS

Igneous rocks, like the pegmatite (bottom left), are often composed of a combination of light and dark minerals that give them a very distinctive texture. Sedimentary rock, like the banded limestone (bottom right), usually has clearly visible flow lines that help to define the direction of its faces.

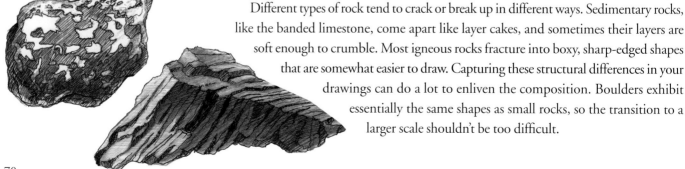

Creating Texture for Rocks

BUILD FROM THE BASICS

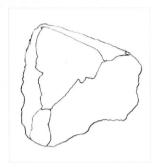

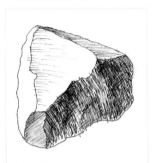

1 Outline the main, visible surfaces of the rock.

2 Roughly shade the rock to help define volume, using different values to make the different side come forward or recede.

3 Make a second outline drawing based on the first one, this time including the minor planes that twist and turn to break up the right side.

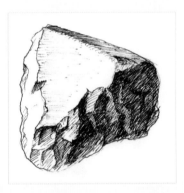

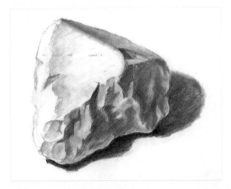

4 Shade the second outline, keeping the minor planes subordinate to the major planes.

5 Use a pencil and a paper stomp to allow for the softer edges and subtler tonal changes.

Rocks in Natural Settings

The fields of rocks that are so often found in natural settings introduce another challenge. You could observe and draw the shape of each individual rock in the field, but I don't recommend it. Instead, identify the major rocks and draw them carefully. Fill in the spaces between them with shorthand marks that indicate a coarsely textured ground without being too detailed. Three tones—light, medium and dark—are usually sufficient for this effect, regardless of how many rocks are present or how varied they are.

The more you take on rocks as an artistic subject, the more you'll realize what an endless variety there is and how they're taken for granted in most landscapes. Don't make the same mistake in your paintings. Make the effort to draw the best rocks you can, and you'll be giving the viewer a glimpse at some of nature's finest creations.

Rocco J. Mirro 2001

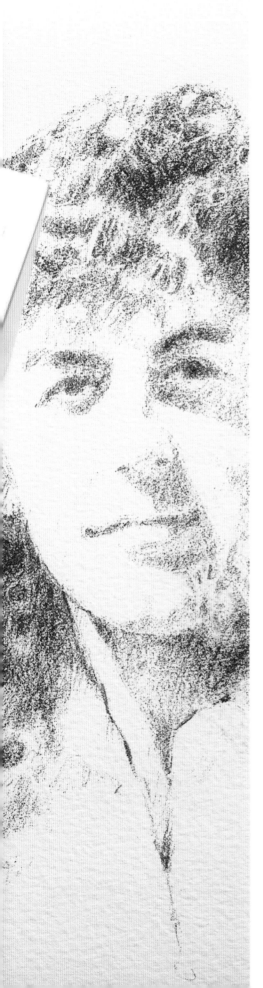

Portraits and Figures:
Your Friends and Neighbors

Have you ever looked into the eyes of a grandparent, a laughing child or a stranger on the street and rushed home to capture them on paper? Sometimes it's possible to look at a new face, or even a face you've seen a thousand times before, in a new way, and see a world of drawing opportunity.

Few things are as challenging as capturing the spirit, drive and personality behind the eyes of a human being. The advice in these pages can help you create drawings that are so lifelike, they seem in danger of stepping off the page.

CAPTURE REALISTIC EYES

Butch Krieger

You've probably heard the eyes called the "windows to the soul" many times, but I hope you've also noticed that this phrase is more than just a cliché. The eyes got that label because they are such an essential part of the expression of an individual's personality. When drawing a portrait, in fact, many artists begin with the eyes, but they can still be a formidable challenge for both the beginning and experienced portraitist alike. Here are some tips that will help you draw natural-looking, compelling eyes and get the best likeness of your subject you can get.

Learn to See

Drawing eyes well requires that you see them well. If you're accustomed to perceiving the eye as a single shape unto itself, you may fail to see it as it really is: a cluster of several shapes on the surface of the face. These superficial shapes, which combine to form what we think of as the eye, can all be defined by the artist in terms of tonal values. In other words, all you need to draw a convincing eye is a good rendering of the lightness or darkness of the surface areas.

The tonal values of an eye are formed in two ways. The first is natural pigmentation. Eyelashes, for example, are usually heavily pigmented and therefore darker than their surrounding skin. The use of makeup, however, can act as false pigmentation and artificially darken or lighten some areas of the eye. Variations in tonal value may also be created by a source of light. As the rays of light fall upon the eye, especially the moist surface of the eyeball, they'll cause a configuration of light and dark shapes that make up what we see, and what you'll draw, as the entire eye. Whatever their source, tonal values can be represented in your drawing by the use of shading, and this is the most important key to drawing lifelike eyes.

Before the shading begins, however, I recommend outlining your shapes. My favorite strategy is to start with the eyebrows and work my way down. I begin by defining the outline of the brow, then the area between the brow and the eyelid, then the upper eyelid, followed by the visible part of the pupil and the rest of the eyeball, and finally the shadowed area beneath the eye. Some of these shapes will share the same outline, and the lighting may be such that two adjoining shapes have the same tonal value and appear to be one large shape. If this is the case, draw them that way.

Go back and shade in each of the outlines you've drawn, looking carefully for the variations in tonal value that make each one appear distinct. Observe the iris in particular, which should be darker around its outer rim but is often drawn by inexperienced artists as one flatly shaded area. Remember not to presume anything, and draw only what you observe.

CAPTURE THE CONTOURS
When drawing a face in profile, don't forget to account for the thickness of the eyelids. The eyeball is set back from each lid, and note that the lower lid isn't directly beneath the upper one but set farther back in the head.

Look for Highlights

Here's an important tip for making your eyes look lively: As you draw each eye, look for its "catch light." Catch lights are little spots of light that reflect off the moist, round surface of the eyeball. Sometimes they're quite bright and sometimes more subdued, but either way these small details can make or break an otherwise excellent portrait.

The best way to add a catch light is to leave a gap of the white paper in your shading. Catch lights will typically straddle the upper edge between the pupil and the iris of the eye. You may see one totally within the pupil, but this usually creates a bizarre appearance in a portrait and is often an indication of improper lighting, such as that of a flashbulb. In this case, it's best to cheat a little bit by moving the light slightly to the side that appears to receive the most illumination. If the eye you're rendering is in the shadows, however, you may not find a catch light and it probably would look unnatural to put one in. If in doubt, try adding the light and shading it out later if it looks inappropriate.

Develop Your Imagination

All this discussion refers to drawing from a model, but at some point you may want to be able to draw realistic eyes from nothing but an image conceived in your mind. This is called the constructive approach, and it can be wonderful as a training exercise because it reveals a lot about your own perceptions. But in my experience, those who can best draw constructively are those who have drawn extensively from life.

If you really want to get proficient, spend some time drawing nothing but eyes. When the eye is independent of the entire face, you won't have to worry about proportion and placement within the face, which is crucial to good portraiture but can be studied separately. Any way you look at it, the only way to master the drawing of the human eye is to draw as many as you can. Train yourself to see them accurately, and you're on your way to drawing them well.

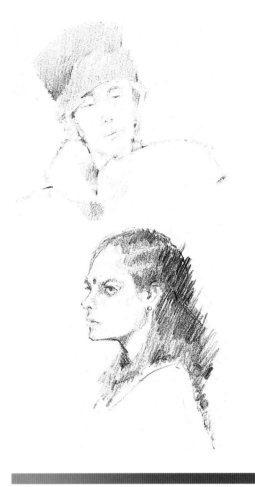

SET THE TONE
The drawings of these two women show how important the glance of the eye can be to the overall drawing. The narrow, critical glance of the woman at top required only a few strokes of the pencil, while the intense expression of the woman below her is enhanced by the darkness and detail of the eyes.

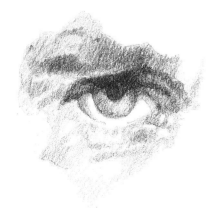

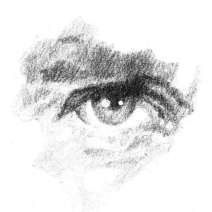

CATCH THE LIGHT
These two eyes are rendered as alike as I could make them, except for one detail: the catch lights. The light in the right eye makes it appear deeper and rounder, and it provides a spark of life. Here I've provided two catch lights, but more often you'll find only one, and you'll want to make sure it comes from the direction of the main light source.

Drawing Eyes

I've found that the best way to practice drawing eyes is to find a volunteer willing to sit still for as long as it takes for you to feel free of the pressure to finish quickly. Place him or her under a single light source (ideally in front of, above and slightly to the side of your subject), then try following these steps.

1 Outline the Eyebrow

With a soft graphite pencil, such as a No. 4, draw the outline of the eyebrow exactly as you see it. Don't shade it in yet; that will come later.

2 Develop the Shape Between the Brow and Lid

Now draw the shape of the area between the brow and the eyelid. Because this is adjacent to the eyebrow, the two shapes will share part of their outlines.

3 Create the Upper Eyelid and Pupil

In the same manner, draw the outline of the upper eyelid and the pupil. If the lid and the pupil appear to merge in their tonal values, as they did in this case, draw them as a single complex shape. Also, take care to draw around the catch light you'll probably find at the edge of the pupil and the iris.

4 Begin the White of the Eye

Next outline the two parts of the sclera (the white of the eye) on each side of the pupil. Often the upper edge of the lower lid is wet and shiny, and this may have the effect of a white border that forms the shape of a cradle beneath the iris.

5 Form the Shadow Beneath the Eye

Outline the shadow area beneath the eye. Note that I haven't drawn the individual hairs of the eyelashes—instead I'll look for the overall shapes formed by the combinations of lashes.

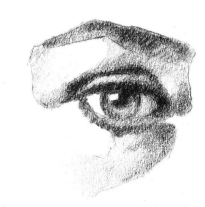

6 Add the Finishing Touches

To finish the drawing, shade in all of the shapes you've outlined. Look carefully for the variations in tonal values, soften your edges where necessary and don't forget to preserve the catch light as your lightest area.

DRAW THE MANY SHAPES OF EARS

If you want to draw portraits, there's no escaping the human ear. With all of its twisted, convoluted shapes, the ear can make or break a good likeness. Unfortunately, because of the perceived complexity of these combined shapes, many artists believe that ears are difficult to draw. This attitude often leads to tight, overdefined ears that detract from the overall image. In truth, of course, ears are no more difficult to draw than any other object. In my many years of drawing portraits, I've developed a simple strategy that can help you produce convincing, natural-looking ears. Here's how it works.

Butch Krieger

Concentrate on Shapes

The first step in the ear-building process is mental: Forget for a moment that you're looking at a human ear. Instead, think of the simple configuration of shapes you see. Look for intertwining positive and negative shapes within the overall form of the ear, and observe the major shadow shapes on the skin. Note also that there are subtle variations of light and dark even within those shadows. Once you're able to separate these elements in your mind, you've cleared a major hurdle, and the task of drawing the ear will be much simpler.

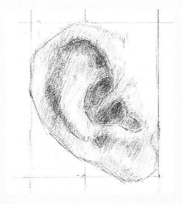

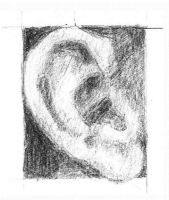

1 Sketch the Contours

Begin sketching the ear's contours, but use these contours sparingly—do just enough to establish the major forms and proper position of the ear. Don't be too heavy-handed because excessively bold contour lines may result in an overdeveloped ear, which will detract from your subject's face. Keep the contour lines light, and draw them only when they represent distinct edges.

2 Shade Within the Contours

Once you've blocked out the border lines of the form, begin shading within them. Then, instead of using dark, defining lines, develop the forms within the ear with contrasts of light and shadow. Carefully render the shapes of the shaded areas just as you see them. Keep a light touch at first, cautiously considering every stroke you make, until you've matched all of the shadows. Save the heaviest shading for the end when you draw the dimmest recesses of the ear.

3 Define the Outer Borders

Use the approach in steps one and two to establish the outer borders of the ear. First develop the forms on the outside of the ear using contrasts of light and shadow. Be sure to lightly contour the outside of the ear, then go back to define the contrasts more heavily. If you don't have sufficient contrast around the ear, go ahead and define it with a line. But make it a delicate line so it won't stand out too much. The important thing is to make the ear look natural and graceful.

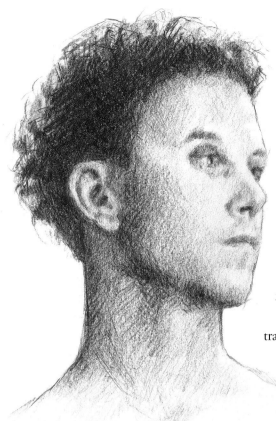

Everything in Its Place

Of course, it's good practice to make lots of sketches of ears. But if you're drawing a full portrait, it's best to establish the basic shape of the face and the position of the features first. Once those elements are in place, use drafting tape to attach a piece of tracing paper over your drawing surface and block out the ear on this cover sheet. This approach allows you to reposition the ear if you discover that you've drawn it in the wrong place. Use high-quality tracing paper—it will withstand multiple erasures.

Next, make sure that the ear is the right size and in the correct position on the head. To do this, simply relate specific portions of the ear to nearby facial features. For example, if the head is held straight, the bottom of the earlobe usually lines up somewhere between the end of the nose and the top of the lip. But if the head is tilted, all of your points of reference will change, so you must observe your subject carefully.

When you're happy with the size and placement of the ear, transfer it from the tracing paper to your drawing. You can do this easily by slipping a piece of image-transfer paper (sometimes called dry-transfer paper, available at most art supply stores) between the two sheets, then carefully tracing over it.

POSITION THE EARS
To ensure that the ears are positioned correctly on your subject's head, first establish the basic shape of the face and the position of the features.

ADDING EARRINGS
If you understand the principles behind drawing ears, adding earrings is an easy process. Just leave them blank as you draw the surrounding shapes, as I did in the illustration at right. Once you've established the white silhouette of the earring, you can add appropriate shading and other details. You may want to simplify more complex jewelry.

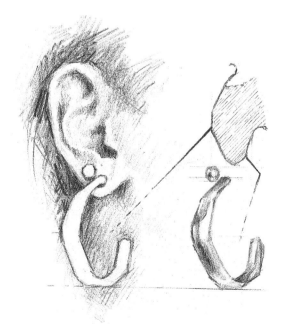

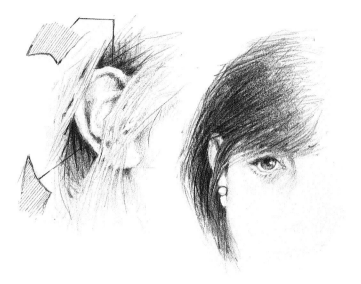

EARS SHADED BY HAIR

In some cases, an ear may be partially covered by the subject's hair. When that happens, the ear appears as a negative shape beyond the positive shape of the hair. This can be clearly seen in the example at left, where much of the ear is visible between two major locks of hair. Observe, too, that this creates smaller negative shapes above and below the ear.

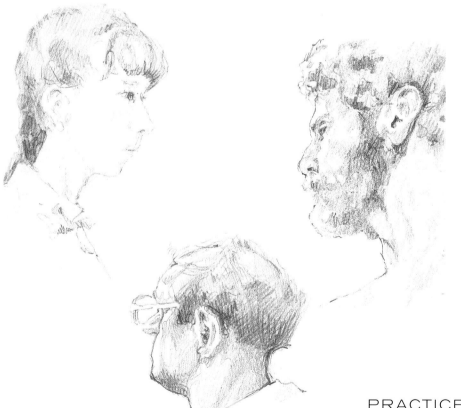

SHADING FOR REALISM

Any way you look at them, ears are integral features of the human head. A person's ears are also an essential part of his or her likeness. Even in candid, freewheeling sketches like those shown here, notice how my shaded approach allows me to integrate the ears into the rest of the head.

PRACTICE, PRACTICE, PRACTICE!

Initially, drawing the human ear may seem a bit daunting. But if you break the ear down into its individual parts, the work becomes much simpler. As with all drawing, practice is key. The more you sketch the ear, the more confident you'll become. This higher level of confidence, in turn, will translate into more lifelike, convincing ears—and more powerful likenesses as well.

DRAW REALISTIC HAIR

Butch Krieger

Lifelike hair is an indispensable feature of a natural-looking portrait. Hair is not only a key indicator of how skillful a realist the artist is, but it's also one of the most expressive parts of a person's body. Perhaps because it's both so adaptable and so prominent in our appearance, the way we wear our hair can reveal a lot about our character, whether we want it to or not. If you really want to capture the essence of a person in a portrait, try starting at the top.

Look at the Big Picture

The most important thing to understand when drawing hair is that it's futile to try to draw all the individual hairs on a person's head, or even to draw half of them. There are simply too many for even the most patient and persistent artist to render, but even if this weren't the case a single hair is thinner than the narrowest pencil line you can draw. You may have seen drawings in which the artist seems to have meticulously drawn a head of hair in very fine detail, but if you look closer you'll find that the artist has merely created the illusion of having drawn each and every hair.

To create this illusion yourself, ignore all those thousands of separate shafts of hair and concentrate instead on the major shapes in the body of hair. You must see the hair in this simplified way before you can draw it this way, however, so a good way to begin is to close one eye and squint while looking at your model's head. What do you see? Is it one distinct outline containing an even distribution of mass? Or is it a major shape with several smaller shapes protruding from it? Or is it a roughly consistent series of waves? Also, don't just note the positive shapes but the negative ones, too. Are there any significant gaps in the hair? Where are the major shadows? Answering these questions at the beginning allows you to bypass all the superfluous details and go straight to what's most useful for you as an artist.

Add Contrast and Texture

Use these defining shapes to begin your drawing. Lightly sketch them in the proper relationship to the head so you'll have a context to work within, but don't expect these edges to be permanent. Experiment with the arrangement and proportion of the hair. Remember, sometimes even the most realistic results don't come out the way we expect them to.

Establishing effective contrasts between lights and darks is one of the most important aspects of drawing hair. Identify the darkest areas and shade them in first. The lightest areas are already there in the white space of your paper, so it's best to work around them. After you've done the darkest parts, shade progressively into the lighter patches to keep your range of lights and darks consistent.

CREATE A NATURAL-LOOKING ILLUSION
To make the hair in your portraits look authentic, you don't need to draw each hair individually. Concentrate instead on the major shapes formed by the hair, as I did in this portrait. Then use shading and some well-placed strokes to make viewers think they're seeing more than they really are.

To build a sense of texture into your shadings, use directional strokes, which indicate how straight or curly the hair is and give the appearance of individual strands. For most hairstyles your strokes should be largely consistent because the hair will all be falling in generally the same direction, and even the smallest variations can be enough to give the hair a natural or tousled look. When you get to the outer edges of the hair, don't be afraid to let the hair fade into the background. Rarely does a person's hair have a hard visual edge to it, and letting the viewer see the hair get thin and wispy can be a great touch of realism.

Use the Basics

Although there seem to be plenty of different types of hair in the world (almost as many as there are types of people), don't be intimidated. The styles may change a great deal, but the fundamental properties of human hair don't change much. The most visible differences are in color and curliness. To draw curly hair, try using circular shading instead of the one-directional or back-and-forth methods, and be sure to do this from the very start. It's more painstaking and often time-consuming, but it's worth the effort if you want a naturally curly look. For extremely curly hair, you may want to forego directional strokes altogether and stick with either a variety of smooth shadings or tightly circular ones.

When you're working in black and white, the lightness or darkness of the hair is just a matter of how heavily and consistently you shade it. Sometimes, however, bright light can be falling on the hair, and dark hair in this situation can be indicated by heavier contrast between these areas and those that aren't in direct light. Also, when you have the occasion to draw facial hair, keep in mind that it doesn't differ all that much from other hair. It's usually a bit thicker and sparser, though, and you'll want to pay special attention to blending around the edges. As before, avoid hard edges except in unusual cases.

THE IMPORTANCE OF STROKE WEIGHT AND DIRECTION
The direction of your strokes can be used to show the flow of the hair and to suggest individual hairs. For the woman at top I used the strokes heavily to make her hair appear thick and straight, while for the man on the bottom I relied much more on shading, much of it circular, to indicate tight, curly hair.

Separating the Values to Create Hair

Even the most complex head of hair can be successfully drawn if you establish effective value contrasts. Begin by identifying and shading the darkest areas, gradually working your way into lighter areas. Once you've established the body of the hair, you may add the details.

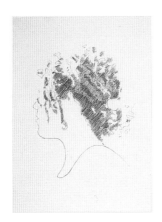

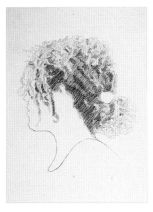

1 Shade the Darkest Areas First

To successfully draw a complex head of hair, identify the darkest areas and outline them lightly. Then shade the dark areas gently with a medium-soft graphite pencil.

2 Shade the Second-Darkest Areas

Identify and shade the second-darkest areas. These should extend outward from the darkest areas. Shade them lighter than the first.

3 Establish the Body of the Hair

Shade areas progressively lighter until you establish the entire body of hair. Work from the darkest value to the lightest (rather than from one area to another) to maintain consistency in light source and in relationships between each section of hair.

REMEMBER THE HEAD

One last tip: Throughout the process of drawing hair, don't ever forget that there's a cranium beneath it. This is what provides the hair's essential shape, so pay attention to the shape of the head and how the hair naturally falls around it. If you can remember this and remain focused on the entire body of hair instead of getting caught up in each separate strand, you'll draw beautiful heads of hair no matter who your subject is.

4 Add Fine Details

Use a soft blending technique to create the poofy edges of the hair. Next shade the woman's face and neck to establish a foil for one of her braids. Do additional shading and blending to soften the directional lines.

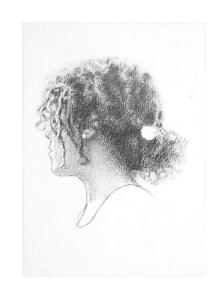

DRAWING A SELF-PORTRAIT

Butch Krieger

You already know that the best way to improve your portrait-drawing skills is to practice with a live model, but sometimes it's tough to find one. So why not use your own face as your subject? Self-portraiture is an artistic tradition that dates back to the early years of the Italian Renaissance. What's more, it can be a very rewarding experience, either as a somber journey of self-introspection or a way to poke some fun at yourself. Just follow these suggestions to get started.

Gather Your Tools

I recommend that you do a drawing first, which is much simpler and more manageable than a painting or sculpture. Choose a soft, blendable, erasable drawing medium, such as charcoal, Conté crayon, graphite or soft drawing pencil. (Don't complicate things by using a colored medium, such as colored pencil or pastel, unless you're already adept at dealing with color.) You'll also need some type of drawing paper—white or toned—and a firm surface, such as a drawing board, to work on.

Additionally, you'll need a mirror large enough to see the reflection of your head and shoulders. It should be in a vertical, or near vertical, position. If you tilt the mirror significantly, you'll probably distort your image. Of course, later on you may wish to experiment with distortion, but you should probably keep your first self-portrait simple.

Your bathroom mirror will likely work just fine, but your bathroom lights are probably too diffuse for this purpose. To improve the lighting, I suggest finding a single, controllable source of light. If you don't have a professional studio lamp, try using one of your household table lamps without the shade.

Make Yourself Comfortable

When posing, sit or stand in a comfortable position with your head facing directly forward toward the mirror. As you become more skilled you can try other positions, but for now, stick with a full-frontal view. Be sure you can hold this pose for a long time, as the slightest shift of your posture will throw everything off in your drawing.

Of course, no matter what pose you take, it'll soon become uncomfortable. When you need a little break, take it! Before you move, memorize the position you're holding. If you're sitting on a chair or stool, don't move it. You may even wish to take the precaution of marking the placement of its legs on the floor with masking tape, just in case it's moved. When you resume working, look at the part of your drawing you've already done, and use it as a guide to get yourself back into your original pose.

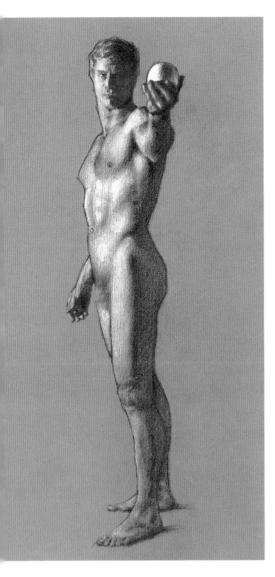

CHEATING WITH TECHNOLOGY

To do this self-portrait, I departed somewhat from my normal life-drawing procedure. First, I photographed one of my male models, then asked a friend to photograph me in the same pose, and scanned both shots into the computer. After electronically merging the photo of my head with the model's body, I used the computer printout as my drawing reference. The creation of *Man* (charcoal and white Conté, 19" x 5" [48cm x 13cm]) was unusual, but fun.

Position the Lighting

Next, you'll want to position the lamp in front of you and off to one side, probably close to the wall beside the mirror. A good height for the lamp's bulb is at about a 45-degree angle above your head. Your objective is to get the light to sweep down and across your face, illuminating and defining your facial features with sharp contrasts of shading. You don't want to see the lamp in the mirror, though, because its reflection may glare into your eyes and wash out those wonderful shadows.

You may find reflected light bouncing back into your face, probably from a nearby wall. Some reflected light is good for this situation because it can help define your facial features on the shadow side, but too much of it will drown out the shadows almost entirely. Keep adjusting the lamp until there's a good balance of light and shadow on either side.

Above all, make sure the lighting is just right before you begin. Readjusting the light after you've been drawing for a while will yield a portrait that's inconsistently shaded.

Start Small

Now you're ready to begin your actual portrait. Your face is so familiar that it's easy to take it for granted, as if you look at it without really seeing it. The key is to forget that you're drawing your own face and pretend you're drawing a face you've never seen before.

To start, you might try making a few small marks to represent the placement of key features, for example, the top of your head, your chin, your eyes, your ears and so on. At this point, you just want to get the proportions correct. For most people, the width of one eye from corner to corner will be the same distance as the space between your eyes and the space between the outer corner of your eye and the edge of your head. (This is called the "five-eye rule.") Also, the bottom of your earlobe will probably align somewhere between the tip of your nose and your upper lip. Careful observation of how your features line up and the distances between them will help you draw your face accurately.

Once you've got your features positioned in approximately the right places with small marks, you can start to fill in the basic values. Some areas, such as your eyes, provide helpful contour lines. But other features, such as most of your nose, are defined by the shapes of shadows, middle tones and highlights. Just work slowly, rendering your features with lines and value shapes until you've captured your own likeness.

Experiment With Detail

If you're apprehensive about drawing a self-portrait, feeling that it's too big of a challenge right now, make it easier for yourself. Focus on one part of your face, perhaps your eyes. How about just your nose or mouth? There's no law or code of honor that requires you to draw your entire face the first time you try it. Self-portraiture, like any art, should be a rewarding experience, not a frustrating, disappointing exercise.

After you've learned to draw yourself from simple, live poses, you may wish to experiment with more elaborate self-portraits. You might arrange two mirrors to give yourself a profile view of your face, perhaps wearing your favorite hat. You might also use some modern technology to expand your options. Photography in particular can enable you to portray yourself in ways and situations that you can't achieve with a mirror.

BE CREATIVE

Once you've got the hang of drawing your own facial features, you can be more creative in designing drawings or paintings around your self-portraits. Here, I've incorporated my profile into a drawing called *Jack of Hearts* (pencil, 9 ½" x 6 ½" [24cm x 17cm]), which I may develop into a painting at a later time.

WORK WITH WHAT YOU'VE GOT

You don't need a studio or a fancy lighting system to start developing your self-portraiture skills. Just place a kitchen chair or bar stool in front of your flat-hanging bathroom mirror. Then use an ordinary table lamp—minus the shade—to light your head and shoulders. Position the lamp so the bulb is at about a 45-degree angle from your head, creating distinct highlights on one side of your face and rich shadows on the other.

PORTRAITS OF THE ELDERLY

Butch Krieger

As it ages, the human face becomes increasingly more complex. Because of this, drawing elderly people may seem much more difficult than drawing younger subjects. But in fact that's not the case, and it's a common mistake for beginners to concentrate too heavily on the details of the aging body—the wrinkles, the age spots, etc.—instead of trying to capture the overall shapes and contours that signify age. It's these elements that reveal character and make the elderly such fascinating portrait subjects.

The Evidence of Time

The complexity of older faces is the result of two things that happen to the skin with the passage of time. To begin with, the general shapes of the face are transformed. From the day you first sat up, your face has been fighting a tug-of-war with gravity, and eventually the skin's own weight pulls it downward. As it does so, the shapes on the surface of the face become more angular, bold and edgy. The tip of the nose, for example, slowly elongates. The cheeks drape downward, and the skin beneath the jaw gradually lowers.

The other big change is in the surface details. Skin loses its elasticity over time and begins to crease and fold over itself. This considerably increases both the number and intricacy of the facial details. Whether a person chooses to disguise these features or to wear them proudly, the portraitist can use them to mark the subject's age and, at the same time, to create a distinguished appearance.

THE SUBTLETY OF DETAIL

In these two versions of a drawing of my octogenarian father-in-law, the one on the left shows two common mistakes in drawing older subjects: using lines to represent wrinkles and including too many skin-surface details. The version on the right looks more natural because it uses shadows and subtle contours instead of sharp lines.

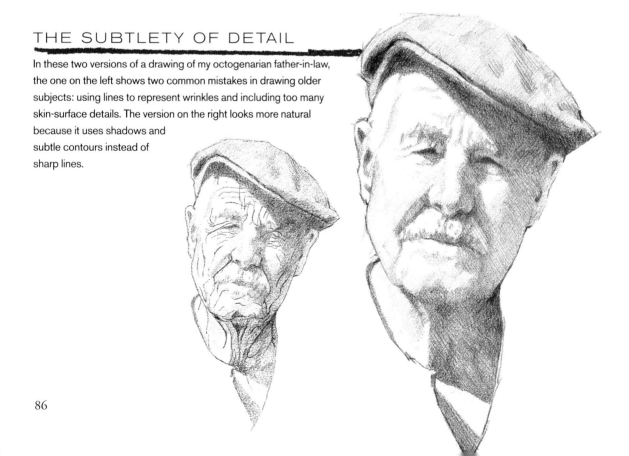

Look for Character

To the novice, all these features may seem like reasons why the older face is too difficult to draw. Here are a few tips for making it easier. First, learn to look past the minutiae of surface skin details and look for the general shapes in the face. Don't study each and every wrinkle, but only the few that most effectively suggest those overall shapes. That's where you'll find the forms that define a likeness. Also, keep in mind that these forms are not only more interesting but easier to discern and draw than the less distinctive features of younger models. They provide much more well-defined shapes for you to work with.

Next, don't think of wrinkles and folds in the skin as lines. Think of them as long, narrow shadows instead. Then draw them that way, with all the shadings and subtle value transitions that shadows entail. If you treat them (inaccurately) as simple lines, you'll create a likeness that appears harsh and artificial, whereas appropriate shadows will look perfectly natural.

Soften and Simplify

Finally, learn to simplify and soften the surface details of the skin. Simplify them by leaving out many of the minute facial lines and age spots. You don't need them all to make a portrait realistic, and they'll only clutter your drawing. Then soften the contrasts of the details that you decide to include. Abrupt contrasts only occur when a very light area is next to a very dark area. Reducing the contrast between the light and shadow areas of wrinkles or age spots will prevent the surface details from overpowering your model's face.

You may have seen and admired a drawing in which the artist rendered every microscopic detail of someone's rugged old visage. But remember that this level of detail isn't necessary for a convincing likeness, and unless you're extremely well-practiced, you're better off to leave such a sharp-focused approach for another day. Instead, keep the details simple and concentrate on just a few defining characteristics, and you'll be pleasantly surprised at how well you can capture the magnificence of the elderly face.

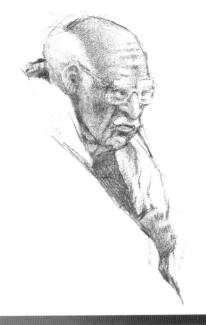

ECONOMIZE THE DETAILS
In field sketching older subjects, it's particularly important to economize the facial details. Most of the wrinkles and folds of this man's face were omitted because they would have cluttered up the small drawing and taken too long to complete, but a few suggested wrinkles around the mouth and neck can stand for all those we can't see.

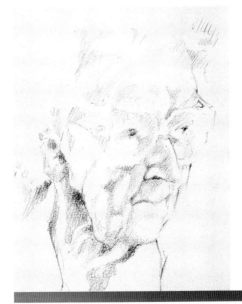

MAKE MORE WITH LESS
In this sketch of the famed environmentalist Hazel Wolf, a few well-placed shadows and contours are enough to portray the dignity of her age without recording all the details of her timeworn face.

MASTER THE FIGURE

Butch Krieger

Realistic figure drawing dates back to the Italian Renaissance and was once considered an indispensable part of every artist's training. Masters from Michelangelo to Picasso honed their rendering skills by drawing the figure. And although figure drawing has fallen from grace in some quarters of academia since the middle of the twentieth century, the reality is that this skill is a necessary one to master. If you can accurately draw the human figure with all of its nuances, you can literally draw anything. Here's how to get started.

Life vs. Imagination

Figure drawing can be broken into two main categories. The first is *life drawing*. As the name suggests, this is the practice of drawing pictures directly from live models. The second type of figure drawing is *constructive drawing*. It builds on the knowledge you gain from life drawing. In this type of drawing, you first use simple geometric shapes to construct the figure that you have in mind, without the aid of either a live model or reference photos. Then you build the actual figure over this framework.

But no matter what type of drawing you're doing, it's critical that you relax and enjoy it. Don't worry about producing finished masterpieces. That adds too much pressure. Keep in mind that mistakes are clearly visible in some of Michelangelo's figure drawings, but this great master didn't even bother to erase them—he merely backed up to the point where he'd gone astray and started the line over again.

RECREATE REALITY
Drawing the human figure is perhaps the best way to hone your ability to re-create what you see on a two-dimensional surface.

88

Tighten Your Focus

The human figure contains so much visual information that you may feel overwhelmed when you try to draw it. In fact, one of the greatest challenges in life drawing is determining where to start. My experiences in both learning and teaching have shown me that it's better to begin with something small, and do it well, than to start with something too big and difficult. With that in mind, it's a good idea to isolate just one segment of a model's body—such as the knee, the torso (front and back), the upper arm, the thigh, the neck, and so on.

If the buttocks in this exercise seems too complex to start with, you may want to try drawing something as simple as the back of your model's knee. Simply choose a section or area of the body you're going to draw, and use the following steps as a guide. The important thing is that you start with something that's easy to manage, then progress to larger segments of the anatomy. If at any point you feel that you've expanded too far, simply drop back to smaller segments for a while.

1 Set Boundaries

Draw two horizontal lines and one vertical line to partition off a segment of the figure. These partition lines are important, as they help you see the segment you've chosen as a four-sided shape unto itself.

2 Build the Form

Work across the segmented form. Add the contours and shadow configuration that you see, but keep the shadows light at this point.

3 Close the Box With Contour

Continue developing the image until you reach the edge opposite the vertical partition line. Use the contour of the buttocks to form the right edge of the drawing.

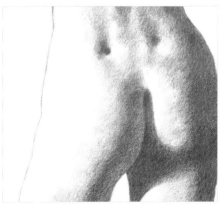

4 Create Volume

Now go back into the drawing and develop it with areas of light and shadow. Notice how these simple value contrasts help create a sense of volume. Use the white of your paper for the light-struck areas, then add progressively darker values as you move into the shadowed areas.

START WITH BASIC SHAPES AND GESTURES

Butch Krieger

FIND THE BASIC SHAPES
To better "see" the human figure, try breaking it down into a series of basic shapes. This example contains two types of basic shapes: The shapes at right are geometric shapes—cones, cylinders and spheres; the shapes on the left are organic shapes. Most often, geometric shapes are used to create a foundation for constructive drawing, but you may want to experiment with organic shapes as well.

As you work with your model, try to visualize each segment of the body as one or more simple geometric shapes. For example, you can combine several shapes to represent the torso, while cylinders work well for the legs and arms.

You may also find it helpful to make gesture and cross-contour drawings. Gesture drawings are usually dynamic and involve the entire figure. Simply look for the directional forces in the gesture, then use basic lines to capture the sense of movement. Cross-contour drawing, on the other hand, can be used for either the entire body or segments of the body. Cross-contour lines help give your figures a sense of volume.

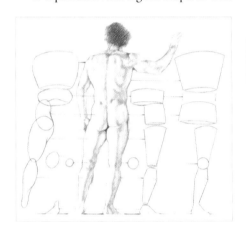

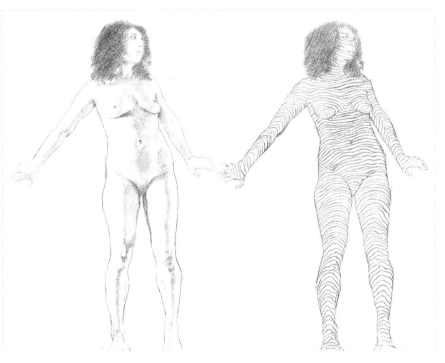

CROSS-CONTOUR DRAWING
Cross-contour drawing trains the eyes to "feel" the contours of the body. Using a live model as your guide, try to draw a pattern of lines across the figure that accurately captures the form. This pattern can also help you determine where to place the all-important shaded areas that are necessary for a convincing illusion of volume.

GESTURE DRAWING
Gesture drawings are particularly useful for developing a sense of life in your figures. First, use loose, directional lines to capture the flow of energy of your subject. These lines then serve as a guide for creating a basic figure.

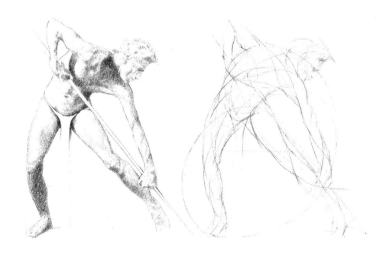

Constructing a Figure

Once you become proficient at seeing the basic shapes and have a grasp of gesture and contour, you're ready to try constructive drawing without a model. Begin by using geometric shapes to create a foundation for the figure. Then lay a sheet of tracing paper over this foundation and flesh out the figure on the overlay. Don't hesitate to deviate from the geometric forms if you feel it's necessary. When your drawing is complete, remove the tracing paper and place it on top of a clean, white sheet of paper. This allows you to see your figure clearly, without the clutter of the initial underdrawing. Finally, you can add shading as necessary to create a sense of three-dimensional form.

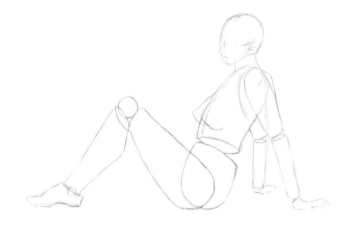

1 Start With Simplicity
Block in the body using simple geometric shapes.

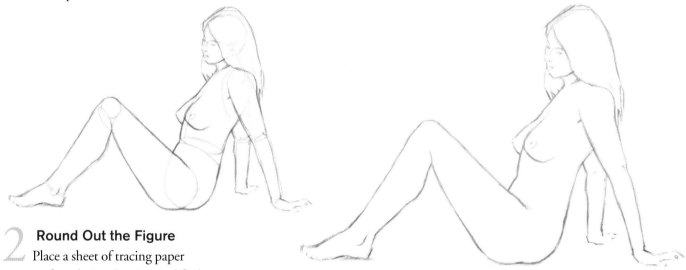

2 Round Out the Figure
Place a sheet of tracing paper over your foundation drawing and flesh out the figure.

3 Examine the Results
Remove the tracing paper, revealing the finished figure drawing.

SIGHTING PROPORTIONS

When completing these initial exercises, don't be too concerned with proportions—the relative size of body parts or features. Instead, focus on seeing and drawing the contours and shadows. However, proportion should come into play when you expand to include several body parts. Probably the easiest way to get proportions is through the age-old process of sighting. To try sighting, simply hold your pencil vertically between your eye and the model. Then slide your thumb along the pencil to measure the feature you're going to draw. Repeat this process to measure the size of another feature and compare the two. Note: When sighting, it's important that you always be the same distance from your model and hold the pencil at the same distance from your eye—if you don't do this, your comparisons will be off.

DRAWING CONVINCING FIGURES

Rocco J. Mirra

SKELETAL SOURCES

I buy my articulated, plastic adult skeletons (for art and for Halloween fun) from www.boneyardbargains.com. If you'd prefer to look at a book, check out *Figure Drawing Without a Model* (David & Charles) by Ron Tiner or *Realistic Figure Drawing* (North Light Books) by Joseph Sheppard.

When it comes to drawing the human figure, it's very important to know and understand the shapes and functions of our bony, muscular frames. So I bought some skeletons online and put one to work to help teach myself as much as I could about each of the bones.

You'll find it's well worth your time to observe the incredible, graceful interior framework we all have. Get a life-size plastic skeleton and apply what it has to offer to your figure studies.

After all, we all have a skeleton, and it helps us move gracefully into many different poses and positions. You've probably noticed how a ballet dancer moves elegantly across the stage, how a bodybuilder is able to lift incredible weights or even how the average person walks. Muscles have a bit to do with all these feats, sure, but none of them would be possible without the bones to give our bodies support.

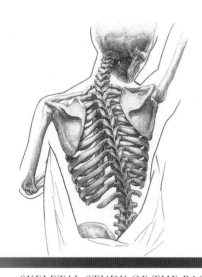

SKELETAL STUDY OF THE BACK
With *Dusk* I saw how the spine and the vertebrae twisted with the rib cage and the two floating ribs. It gave me an idea of what may have been under the skin and muscles to cause the shadows that had distracted me. Also, with the arm raised, on the back of the skeleton I could see that, depending upon the position of the arms, the scapula (shoulder blade) slightly pulled away from the rib cage and seemed to be brought either inward or away from the spine.

Skeletal Study for Dusk
Pencil
6" x 4" (15cm x 10cm)

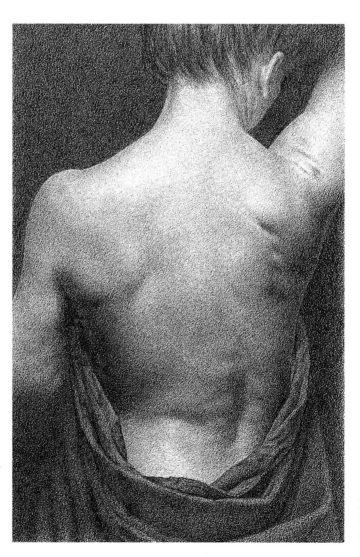

Dusk
Pencil
6" x 4" (15cm x 10cm)

92

Anatomy of a Figure Drawing

With these portraits (*Dusk*, on the opposite page, and *Dawn*, below), I used reference photos of my model to create the primary sketches, starting with an HB pencil and then building up on the shadows with a B pencil. I was having difficulty with some shapes as I sketched and didn't understand what it was that caused these funny-looking bumps and strange shadows. Were they muscles? Were they bones? They grew more distracting as I started working on the darker values. Frustrated, I dug out one of my life-size skeletons and posed and lit it the same as the model in the reference photos. I knew I wasn't going to get the exact pose, but I tried to come as close as I could. I had hoped this approach would help me draw these portraits more convincingly.

By posing my bony friend for the portraits, I was able to see how the bones all move together even with the slightest position change—from the skull to the pelvis, the sternum to the humerus (upper arm)—each having its own part.

As each portrait began to emerge on the cold-pressed illustration board, I built up the layers of the shading to get to the darker values I felt comfortable with and blended the lighter areas. All the while I continued to keep one eye on the reference photo and the other on the skeleton, trying to envision how and why the bones may have caused the muscles and skin to look the way they did.

This approach enabled me to finish the work with more confidence and know-ledge of the human skeleton because I could see what it might look like inside each pose. There are still more bones in the body and their names and functions to know and learn, which can only mean there are many more human figure portraits for me to create.

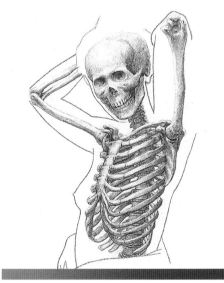

SKELETAL STUDY OF THE ARMS AND CHEST
In the portrait of *Dawn* with both arms raised, the clavicles (collarbones) rose up slightly where they attached to the scapula and moved in the direction of the shoulders and arms.

Dawn
Pencil
6" x 4" (15cm x 10cm)

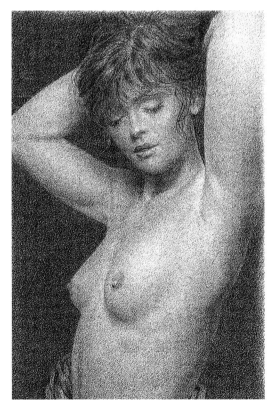

ADD PERSONALITY TO YOUR DRAWINGS

Bart Lindstrom

Drawn portraits walk a fine line when it comes to balancing accuracy and personality. But if you pull it off, everybody wins.

There are two goals for a commissioned portrait: The first is a convincing likeness of the subject. The second is a beautiful artistic statement. With any luck, these elements aren't mutually exclusive. If the piece is artistically beautiful, the client probably won't mind that the rendered details are minimal.

In my charcoal and Conté crayon portraits, I'm trying to portray the subject while at the same time showing the softness and beauty of the human face. Perhaps the most important part of the process is placing the landmarks of the face—corners of the mouth, nostrils, pupils of the eyes—in the correct positions and proportions. Once this is achieved, you can slowly pull the figure out of the mist.

Beginning the Portrait

When working from a live model, try to draw life-sized if possible. This really helps with getting the proportions of the face correct. If forced to rely on a photo reference, make an enlarged copy of the photo so you can apply this same approach. You can also make several photocopies of the shot, ranging from dark to light, for additional information.

For the first stage, draw with the board upright on an easel, so you can check the portrait in a mirror as you work. This gives you the freedom to walk back and forth from the art for a fresher, all-encompassing look. Every time you do this, seek out the landmarks, lines, basic shapes and large highlights. The highlights can be lifted with a soft rag or kneaded eraser. Keep everything soft, saving the hard edges for last.

Just as important as the placement of the facial landmarks is the distance and shapes between them. Squinting is a really big help. Resist the temptation to do any finishing details until you're sure the proportions are dead-on. This precise drawing will be your guide as you begin to model the face. Placing and adjusting all these elements takes time, but it's time well spent. Few things in art are as frustrating as slaving over the finishing touches of an element, only to realize later that it's in the wrong place.

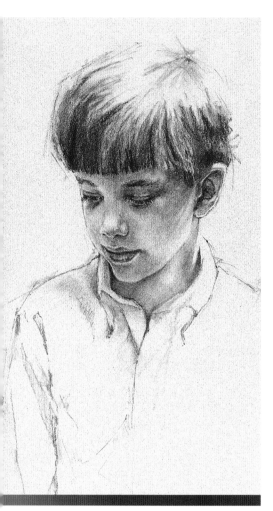

PORTRAY AUTHENTIC
EXPRESSIONS
One of the keys to capturing the person behind the photo-ready smile is to spend some time chatting. I try to keep a subject distracted with questions. This way I get more true-to-life expressions and poses. It worked for the delightful seven-year-old shown here.

John
Charcoal
17" x 14" (43cm x 36cm)

Work through Doubt

Halfway through this process I reach what I call the ugly-duckling stage. This is a time of doubt; all the elements are rough and not very beautiful. This is invariably the time when my 14-year-old son will walk into the studio. Studying the drawing, he'll say, "Are you doing this one just for fun?" I give him the artist's all-purpose answer: "It's not done yet." I tell myself to ignore those feelings of doubt, check for accuracy and keep moving on. The fun part is just ahead.

Place the drawing on a table so you can sit down and work more closely with it. Restate the landmarks, starting with the pupils of the eyes and the line between the lips. Keep checking for correctness in size, shape, proportions and distances. Work slowly around the face to bring the piece together. Stop before taking it too far. More art is ruined by overworking than by underworking. Leave some of the details unstated to make the portrait more lifelike and, hopefully, more beautiful.

Once you're confident about your landmarks, focus on modeling the face by lifting light areas with an eraser and softening with a stump. At this point, you should still be drawing and checking relationships and shapes, both positive and negative. The corner of a paper towel works well for cross-hatching and modeling subtle edges and masses. Check the landmarks, to ensure they haven't drifted out of position. Always correct as you go and try never to leave anything "wrong" on the work; it might incorrectly influence future decisions.

If the drawing does get too detailed or overmodeled, soften the face with the corner of a tissue, pushing back the rendered elements. The trick is not to go too far and oversoften the image.

Finish the Form

Now you're getting close to finishing the face. Don't focus on details for any one element until you have an overall feeling that really appeals to you. Only then should you start zooming in to fulfill the likeness and give a sense of reality and dimensionality to the art. "Detail" is simply finding smaller shapes inside the larger ones. At the beginning stages of a drawing, working on details can make you feel safe. But as you near completion, you discover how little detail you really need to capture a likeness.

By squinting, you can begin to see the face three-dimensionally. This is the time to choose areas to leave untouched. If you're not sure what to do next, leave the artwork and come back to it later with a fresh eye. However, once you've fixed any problems, it's best to leave it alone.

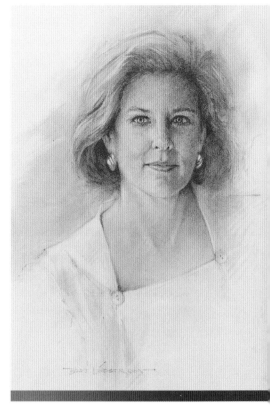

FIND THE RIGHT POSE
The subject's temperament can be the best clue to the perfect pose. The subject of *Sally* (charcoal, 20" x 16" [51cm x 41cm]) seemed to require a straight-on view with eye contact, to express her openness and genuine interest in people.

Cropping Options

When you are satisfied with the drawing, play with the cropping options by putting two large L-shaped mats on the drawing. Sometimes I'll go as far as trying different frames around the piece.

Another way to decide on cropping is to photograph the drawing, make photocopies and cut them into different shapes. Then you can see many possibilities at the same time.

LEAD THE EYE

Making sure your eye goes where it's supposed to is a must. For *Elizabeth* (below right; Conté crayon, 22" x 18" [56cm x46cm]), this meant keeping body details sketchy. For *Jason and Elizabeth* (below left; charcoal, 28" x 23" [71cm x 58cm]), I placed the smaller person in front and to the left (the dominant position in the West, because we read left to right), so she wouldn't be overshadowed.

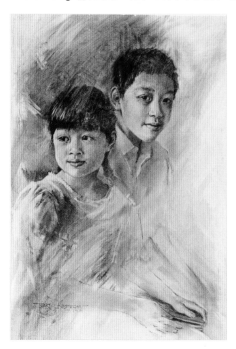

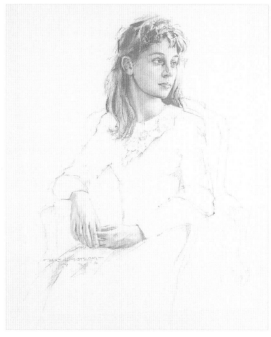

Creating Lifelike Drawings From Photos

1 Determine the Values
When working from a photo reference, make several copies ranging from very light to very dark. This helps determine the value patterns and find the best look.

2 Look for Background Patterns
Begin by mixing charcoal dust with a little water on a smooth board, looking for interesting textures and random patterns. Even when it's dry this surface will be fragile, so use a light hand when you start the drawing.

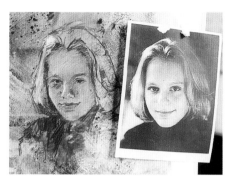

3 Do the Initial Sketch
Sketch the young girl's face using a soft twig charcoal, which lets you make corrections and erase things easily. At this point, the background looks too busy and needs to be altered. However, don't fix it yet. These decisions are best kept until you're closer to finishing the portrait.

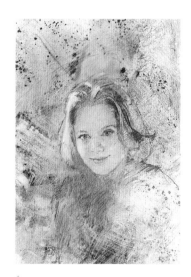

4 Soften and Redefine
Switch from the willow charcoal to a pencil that's been sharpened to a point with sandpaper. This is the fun part—modeling the face until it's just right near the end. Remove some of the background where necessary.

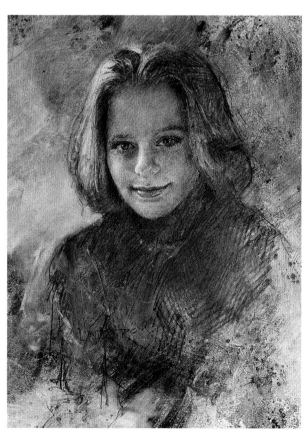

5 Take a Last Look
Use L-shaped mats to determine the best cropping before framing.

Emily
Charcoal, 18" x 14"
(46cm x 36cm)

DRAW EXPRESSIVE HANDS

Andre Kohn

The hands are the most intricate visible structure of the human body. Not just marvels of design able to perform complex mechanical actions, they also have the uncanny ability to express the characteristics and emotional states of their possessors. By looking at a person's hands, you can guess such things as age, experience, social status and even mood.

That's why it's absolutely essential for portrait artists to draw hands well. There's nothing more harmful to an otherwise beautifully painted portrait than having poorly drawn hands. Students and beginning artists tend to approach the study of hands with less enthusiasm than such things as the head or the torso, but that's a mistake, and here's why.

Do the Research

Sir Joshua Reynolds, eighteenth-century master portraitist and president of Britain's Royal Academy of Arts, constantly stressed the importance of studying anatomy and wouldn't let his students advance without knowing it. "If you know the form and the structure of the object that you are drawing or painting from the inside," he said, "the outside will be surprisingly easy to work on." My own teachers referred to this as "structural imagination," and it's vital to all representational artists.

Along with drawing from live models whenever possible (or taking a trip to the morgue), get a well-illustrated book on human anatomy for artists. Choose one that has precise information and a substantial section on hands, and make this book your bible as you practice. You don't need to remember the exact medical terms of each muscle or bone, but understanding the structure, the major connections and the breaking points is essential. As an exercise, I recommend drawing only the bone structure of the hands in a particular artwork before turning to your final version.

Concentrate on the Whole

When drawing, always start with lightly sketching the major forms, then gradually move on to the smaller forms. Many students make the mistake of doing very detailed work on one finger and then another but end up losing the general character of the whole, which is just as important. Remember that we look at our hands perhaps more often than anything else in our lives, and we know intimately how they operate, so it's crucial that all the individual parts are working well together.

Pay attention to the differences between the hands of men and women, and of children and the elderly, for it's these that not only define the hands but the person. The typical loose skin and boniness of elderly hands give them an easily visible anatomy and interesting dramatic lines, more so than the soft, smooth hands of children. In short, the lines and shapes of older people's hands are more likely to tell their stories. Women's hands, in general, appear more elegant, thinner and with narrower palm areas and longer fingers than men's.

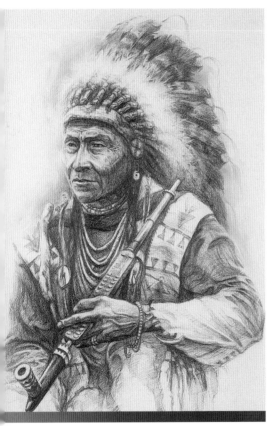

USE HANDS TO REVEAL PERSONALITY
Both in their physical characteristics and in the way they're held, the hands can reveal a great deal about a subject, as in this portrait of a rugged but graceful Native American.

Keep Sketching

Ultimately the best strategy you can adopt for mastering these skills is to practice, practice, practice. Sketch your own hands and those of your friends and family, and put them in a variety of different lighting situations. Also, you may be familiar with copying the work of the masters as a training exercise, but it's particularly useful for specific elements of a picture, such as a portrait subject's hands. In the work of such artists as Sargent, Rembrandt, Michelangelo and Dürer you'll notice that while all possessing the same major characteristics, the hands of each subject have their own inimitable character.

As artists we hope to see, interpret and reflect the world around us with more insight than the average person has. That requires not just seeing the world but also knowing it, and this is sometimes the most difficult part of the job. A thorough knowledge of your subject makes the task much easier. It's the key to successfully drawing a subject as complex as human hands, and it should be a crucial part of your artistic discipline.

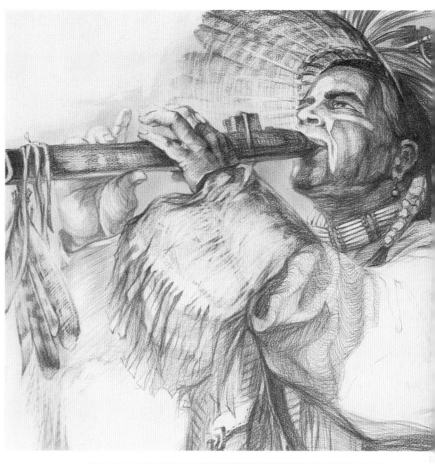

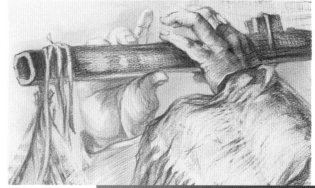

DRAW THE BONES

There's no better preparation for drawing hands than knowing their anatomy. This student drawing demonstrates a valuable exercise—drawing only the bones before rendering the whole thing.

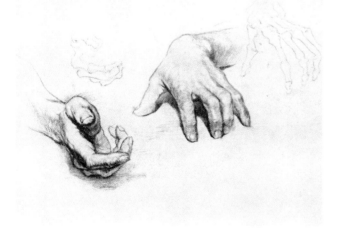

GESTURES DEFINE MOOD
With their remarkable range of motion, hands can define the mood of a piece even when they're not the focus of attention. Here they help create the drawing's sense of music as they dance across the flute.

MATCH CLOTHING TO THE FORM BENEATH

Butch Krieger

Drawing the human figure is one of the most basic—and challenging—of all artistic endeavors. So it's not surprising that clothing figures in a convincing way also presents a unique set of problems for you to solve. In the drawing classes I teach, I find that two problems surface again and again. First, the clothing may look flat and flimsy, lacking any sense of the body beneath it. Second, ineptly rendered clothing tends to make even the most lithe, graceful figure look awkward and clumsy. In most cases, these problems stem from a lack of understanding of the relationship between the fabric and the form beneath it.

My approach begins with a traditional figure drawing of a nude model (if you don't have ready access to a professional model, a relative in a tight-fitting bathing suit will do). When I've finished this drawing, I cover it with a sheet of tracing paper that I attach at the top with a piece of drafting tape. This allows me to lift the tracing paper and look back at my original drawing whenever necessary. Next I have the model return to the stand and take the same pose, this time fully clothed. On my tracing paper, I draw the clothing using the underlying nude figure as a guide. When I finish this overdrawing, I remove the tracing paper and tape it to a clean white sheet. If I've done the drawing correctly, the clothing will appear to stand on its own, as if it were inhabited by an invisible figure.

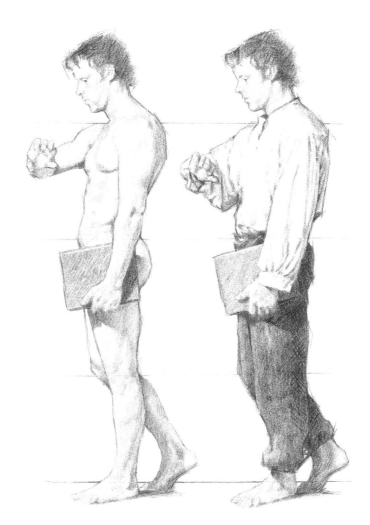

SHAPE YOUR CLOTHES
Properly rendered clothing should retain the naturally graceful dynamics of the human form. Even loose-fitting clothing should look as if there's a solid anatomical shape inside it. To do that effectively, look for the tension points created by the joints and other protruding body parts. In these examples, compare the bent knee and elbow, and the slopes of the shoulders.

Adding Lifelike Clothing

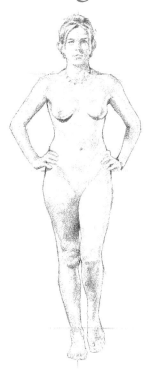

STEPS TO LIFELIKE CLOTHING

- **Use graphite instead of charcoal.** Graphite allows you to get finer detail and is less likely to smudge.
- **Have your model wear simple, plain attire.** Busy details obscure the subtle configurations of the lights and shadows that normally appear on fabric.
- **Have your model avoid dark clothing.** The excessive shading required for darker attire shrouds the anatomical forms behind it.
- **Have your model keep any long hair away from the collar and shoulders.** Free-flowing locks never fall the same way twice, are time-consuming to draw and can obscure some of the clothing's critical contours.
- **Start with simple poses.** Contorted poses may be fascinating to look at, but they're also harder to draw. Moreover, they may be difficult for the model to hold for extended periods.
- **Have your model pose without shoes.** Shoes instantly change a pose—not only do they raise the model's height, they also alter the posture.
- **When drawing clothing, don't try to draw the folds.** Instead, try to identify them by drawing the negative shapes between the folds. Concentrate only on the major folds that describe the basic shapes of the clothing.
- **Pay attention to the lighting.** Keep in mind that you'll need a good contrast between lights and shadows to help you better define the forms.

1 Render the Basic Figure
Whether working from a model, reference photo or your memory, draw the figure.

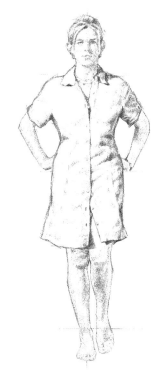

2 Add the Clothes
Tape a piece of tracing paper over your drawing and sketch the subject's clothing onto it. Lift the paper occasionally to compare the garment with the figure underneath.

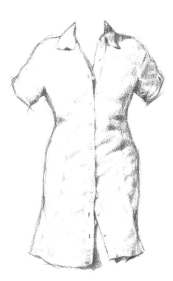

3 Lift the Tracing Paper
When the clothing is complete and you've made sure it matches the figure, remove the paper. The clothing will literally stand on its own!

Colored Pencil and Mixed Media:
Color Your World

Looking for a way to combine the clean lines and realistic forms of drawing with the powerful emotional impact of color? Let these artists share their secrets for bringing their drawings to life with the use of colored pencils and mixed media.

There's nothing like the drama and impact of many lines coming together to form a recognizable subject. Now, learn how to infuse that subject with glowing, brilliant color.

EXPLORE COLORED PENCILS

Janie Gildow and Barbara Benedetti Newton

There are many brands of colored pencils on the market. Some are for coloring maps. Some are for making fine art. You need to buy the best fine art pencils you can afford. Purchase the largest set you can afford—that way, you can replace them one at a time. Consider the following characteristics when purchasing your pencils:

Transparency: Is the pigment finely ground and the binder free from cloudiness?

Lightfastness: Lightfastness is an important issue. No one wants to create art with colors that change and fade over time. It is a good idea to choose a palette of the most lightfast colors and to never hang any artwork in direct sunlight.

Compatibility: If you use more than one brand of pencils in a piece of work, check them for compatibility by layering them together and ensuring transparency and coverage.

Wax: Wax-based pencils use mostly wax in their binders. The wax is semitransparent and allows for transparent layering on the drawing surface. One consideration in using wax-based pencils is the possibility of wax bloom, which occurs with a heavy application of color. It is preventable and correctable by using spray fixative.

Oil: The oil-based pencil uses oil in the binder instead of wax. It is similar to the wax pencil and can be used in combination with many of the wax brands.

Water-soluble: The water-soluble pencil uses water-soluble gum as a binder. It may be used in its dry form to draw or color, laying down pigment on the drawing surface. As the pigment is thinned by water and moved with a brush, the resulting appearance is that of a watercolor painting. In addition to dry-on-dry, water-soluble pencils can also be used wet-on-wet, wet-on-dry or dry-on-wet for additional effects.

EXPLORE THE PACKAGING
Colored pencils vary in their packaging, from cardboard or wood boxes to metal tins.

CHECK THE DETAILS

Is the Lead Centered?
Look at both ends of the pencil. Is the lead centered? If the lead is not centered, the pencil will not sharpen evenly and the lead or the wood may splinter. Some pencils are finished on one end, however, which makes checking the lead impossible.

Are the Wood Halves Similar?
Look at both ends of the pencil to check the wood. Do the two halves look similar? If they look very different, choose another pencil. Halves that are too dissimilar will not sharpen well; they may expose lead unevenly, weakening or breaking it.

Is It Straight?
Sight down the pencil or roll it across a flat surface. If it looks curved or wobbles when it rolls, select another pencil. Curved pencils do not sharpen evenly.

EXPERIMENT WITH PAPER

There are many different types of paper available to the colored pencil artist. Experiment with many kinds to find the one that works best for your style.

*Janie Gildow and
Barbara Benedetti Newton*

Hot-Press Surface

Hot-press surfaces are smooth with very little tooth (surface texture). Some are actually slick, which makes erasing more difficult. Hot-press papers accept less color.

Cold-Press Surface

Cold-press papers accept pencil well, and you can usually apply as many layers as you want. Being rough and hardy, they hold up well to erasing.

Rough Surface

Rough surfaces have definite hills and valleys and a very observable pattern. They accept a lot of color, but if you want solid coverage or a more smoothly blended appearance, choose a paper with less texture.

Prepared Surfaces

Sanded paper (made for pastels) and **Sabretooth** (colored paper with a raspy surface) are used by some colored pencil artists. The grainy surface accepts a great deal of color, but at the same time, it also tends to wear down pencils quickly.

Clayboard (a multimedia clay-coated board) is available in smooth and textured surfaces. They are sturdy and made for additive application (oil, pastel, ink, watercolor, acrylic, tempera, colored pencil) and also for subtractive work (sgraffito).

Rag Paper

Rag paper is made from fibers of nonwood origin, such as cotton rags, cotton linters (the fibers that are left on the seed after the long fibers used for textiles have been removed) or linen or cotton pulp.

Acid Free

Paper that has a greater ratio of alkaline to acid (or a pH from 7.5 to 8.5) can be called acid free. Acid-free paper is made from plant fibers (cellulose) including wood and cotton. Acid is paper's greatest enemy because it attacks the fiber strands, which then come apart, and the paper deteriorates. In nature, fiber strands are held together by lignins, which act as a glue. When the plant dies, the lignins develop an acidity that must be removed or neutralized before the paper is made.

SMOOTH PAPERS
A paper with a hot-press (plate) finish is smooth (some would describe it as slick) and will not hold as much colored-pencil pigment as a paper with more tooth or texture.

ROUGH PAPERS
You will find that the appearance of colored pencil applied to a rough paper will vary depending on the texture or pattern of fibers.

EVEN COLORED PENCIL APPLICATION

*Janie Gildow and
Barbara Benedetti Newton*

Even application of pencil depends on the surface to which you are applying the pencil, the sharpness of the pencil point, the pencil pressure on the drawing and the stroke.

Differences in Paper Tooth

Each paper has a texture or tooth that, under magnification, resembles mountains and valleys. Smooth paper has low hills and shallow valleys—resulting in less texture. Rough paper has higher hills and deeper valleys—greater changes in contour equal more texture. A paper with lots of tooth gives a rough, textured, spontaneous appearance to your color application. A slick paper with little tooth takes fewer layers of color, since the valleys that hold the color are shallow.

Strokes

The way you apply pencil helps to identify your work and set it apart from the work of others. A smooth, even application is important for realism. A more vigorous or spontaneous application works for more expressive art. For an even application of tone, a circular or linear stroke may be used. The stroke should not be identifiable in the finished drawing.

DIFFERENT STROKES

Up and down Then diagonal

Using a Linear Stroke
If you use a linear stroke to create even tone, the strokes must be close together and applied with light pressure using a sharp tip. As the second layer of the same or a different color is laid down, unite the strokes of color by turning your paper and approaching the application from a different angle.

Overlapping Strokes
With the linear stroke technique, if you do not turn your paper and instead make all your strokes in the same direction, you will develop bands of heavier color concentration where your strokes overlap.

Using Circular or Oval Strokes
By making a series of small overlapping circles or ovals, you can avoid any uneven overlap. Filling in tooth is easier and application is smoother when you use circular or oval strokes. As you work, don't try to adhere to exact, precise lines or rows. Take into account the shape of the area you wish to cover and fill accordingly.

Rough (cold-press) paper

Smooth (hot-press) paper

106

PRESSURE AND VALUE CHANGES

Varying the pressure you put on your pencil can change the look and feel of each of your drawings.

Janie Gildow

Applying Pressure

The way you hold your pencil, the direction of your stroke and the amount of pressure you use to make a mark can make a great deal of difference in how your finished painting will look.

If you grip the pencil tightly, you are probably going to make a darker mark than if you hold it gingerly.

If you press the pencil firmly to the surface as you make a mark, the color will appear darker and more concentrated than if you use light pressure. Colored pencil artists vary the pressure of the pencil for two reasons:

1. Amount of Coverage

Lighter pressure means less complete coverage, and that lets the texture (tooth) and color of the paper show through the painting. Heavier pressure means more complete coverage with little or no tooth or paper color showing.

2. Change in Value

Lighter application of the pencil results in a lighter value of the pencil color. A heavy application looks darker (lower in value) but can never be any darker than the pencil color itself.

Adjusting Values

Besides changing pressure to change values, you can also utilize the color of the paper to change your values. On a white surface the color lightens; on a black surface the color darkens. On a colored ground, the paper color adds its tint to the pencil color.

You may also choose to mix white, black or grays (the achromatics) with your color to adjust its value, but this can dull or bleed out your color. So, rather than mixing the achromatics with a color, try mixing other colors with it. For example, use Indigo Blue and Dark Umber as an underlayer to establish values and make a unifying color base for the local color mix, thus augmenting and enriching any added color.

CHANGING THE VALUE
On the left, value changes are made by changing pencil pressure using just one pencil (Peacock Blue). It becomes even easier to change value if you can find different values from the same or nearly the same color family. Then you only have to vary pressure where one color blends into another. On the right, Peacock Blue changes to Aquamarine and then to Light Aqua.

PENCIL POINT

Sharpen your pencil often. A blunt pencil point has trouble getting down into the valleys (crevices) of the paper, so for more complete coverage always work with a nice sharp point. I like to think of sharpening as "refreshing the point." A sharp point allows you to apply color down into the tooth and makes for much smoother-looking coverage.

COLOR MIXING

*Janie Gildow and
Barbara Benedetti Newton*

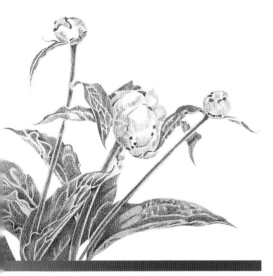

There are several different ways to mix colors in your drawings.

Layering to Mingle Colors

The color put down by colored pencils is translucent, much like watercolor, and like watercolor, using only one color gives a simplistic coloring-book effect. To create interesting hues, use colored pencils to their full potential by layering two or more colors on top of one another. This is the process of building a new color from the bottom up. The mixture of color you end up with depends on how evenly and heavily you apply each layer of color, and in what order. As you become more skilled, you may find that you can reach the desired hue in fewer and fewer layers.

LAYERING TECHNIQUES

ONE-COLOR LAYERS
In this drawing, one green, one red and one pink were used, but not mixed together. Colors were applied with attention to value for a given area, but regardless of how many layers of green are applied, it will never get darker than its original value. Without added value, the leaves and stems look flat.

Crimson Red, Parrot Green and Limepeel layered together.

Olive Green layer

Building Texture and Color
Interesting texture and color come about by layering colors in a random pattern.

French Grey 50%

Black Grape
Limepeel

Indigo Blue
Salmon Pink

Making Grays
Beautiful grays are made by layering complementary colors.

MULTICOLOR LAYERS
This drawing was created by layering two or more colors on top of each other to build interesting color as well as improved values.

Juxtaposing Color

Though colored pencil is a translucent medium with all the joys of building color layer upon layer, there are other methods of applying color. One manner is to place one color next to another color rather than directly on top of it. This side-by-side placement is called *juxtaposing color*. When one color is placed adjacent to another, the viewer's eye does the mixing rather than the artist. But before the mind's eye unites the colors, there is an excitement about the way two or more colors play against each other.

Colors of the same family bordering each other produce a slight undulating effect. Complementary colors or colors of extreme difference in contrast or temperature appear to recede and advance, making the color bounce.

Open Crosshatching

This technique produces a carefree, animated approach to a subject. Your strokes may be curved or straight, crosshatched or left open-ended. Though you can take liberties with volume and form, letting the dynamic stroke dominate the scene, this technique isn't as random and unplanned as it appears at first glance. Colors are mixed both one on top of another, as in traditional layering, and at the same time play against one another as in vertical line and juxtaposition of color.

Yellows that are placed on the paper first may show or peek through subsequent strokes. Likewise, after a number of layers of strokes are applied creating value, white or light colors can be crosshatched over the top for effect.

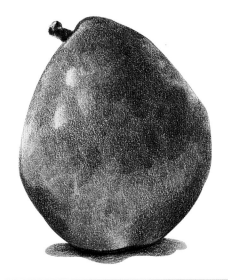

JUXTAPOSING COLOR
Place colors next to, as well as on top of, each other.

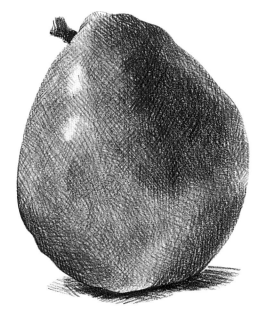

OPEN CROSSHATCHING
This technique gives the appearance of spontaneity but is actually quite controlled in the application of strokes.

SMOOTH COLORED PENCIL APPLICATIONS

Colorless Blender

As you apply the pencil to the paper, it puts down a layer of colored wax. If the paper is rough (toothy), it will have distinctive hills and valleys; the pencil will tend to hit the tops of the hills and won't fit down into the valleys. Even smooth paper has a tooth and, for more complete coverage, requires care and patience to work the pencil down into it. Using a Colorless Blender as the last step smoothes the color.

Burnishing

Burnishing is an application of the pencil using very heavy pressure with the intent to totally fill the paper's tooth with color. Burnished color is very vibrant and saturated and appears darker than layered color. No paper texture is evident at all; the surface is totally covered and sealed with a heavy layer of wax. Burnished areas look like enamel paint and exhibit their own fascination and appeal.

Impressed Line

Impressing a line into the surface of the paper or board makes it possible to stroke a pencil over the indentation to produce a fine line that is the color of the surface and not the color of the pencil. Leaf veins, cat whiskers and fine lace details are perfect for this technique. To impress lines, place a piece of tracing vellum over your drawing. Use a soft lead pencil to draw fine lines exactly where you want them. Then press down harder to impress the lines into the paper, but don't break through the vellum.

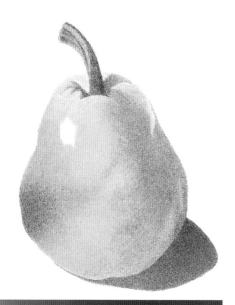

USING COLORLESS BLENDER
The Colorless Blender is applied to already layered color in order to blend and spread it and fill the paper's tooth. The texture of the paper is still apparent, but the white specks are now filled in with color.

Impressed Lines on White Paper

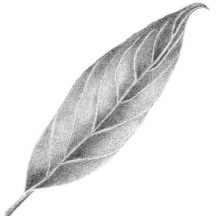

Impressed Lines on Applied Color

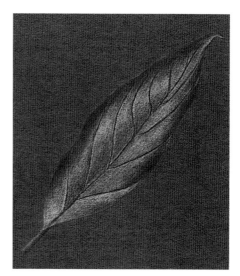

Impressed Lines on Colored Paper

Finding Exquisite Color Combinations

Colored pencil, because it is a dry medium, has to be mixed by layering one color over another on the surface of the piece of art. The wonder and delight of the colored pencil lie in the beautiful color combinations you can make with layering. Since the wax is semitransparent, you can see down through one layer into another, and another, and so on. The color combinations are endless and the mixtures exquisite.

As with most mediums, the darker pencil colors are stronger and will tend to cover the lighter colors. Also, some colors are more opaque (less transparent) than others. They, too, cover better.

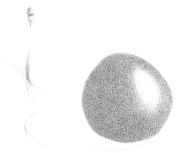

1 Establish the Color Base
Using Mahogany Red, lay in the local color of the cherry.

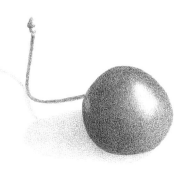

2 Develop Volume
With Black Cherry, create a deeper hue, being careful to preserve the highlight.

3 Complete the Local Color
Use Crimson Red and Scarlet Lake to finish the color.

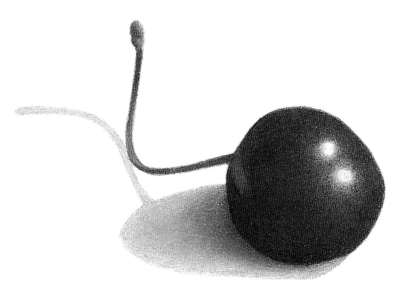

4 Finish the Cherry
Use a pencil with a light-colored pigment, white or clear, to burnish the fruit and give it a waxy appearance.

Me and My Shadow
Janie Gildow, CPSA
2" x 4" (5cm x 10cm) | Colored pencil on 140-lb. (300gsm) hot-pressed watercolor paper

Capturing Reflections With Colored Pencils

MATERIALS LIST

Colored Pencils

Apple Green, Black, Celadon Green, Cloud Blue, Dark Green, Dark Umber, French Grey, Indigo Blue, Jasmine, Light Umber, Limepeel, Marine Green, Olive Green, Peacock Green, Sepia, Spring Green, True Green, White

Painting water in colored pencil may seem difficult, but still water like this lake is actually quite simple. Make sure your reflections truly reflect what's happening above the water line, and you need to keep your ripple lines horizontal, but that's about it. Any reflections that are light in value are easily burnished with White over the top of darker colors, so that part's a snap!

REFERENCE PHOTO

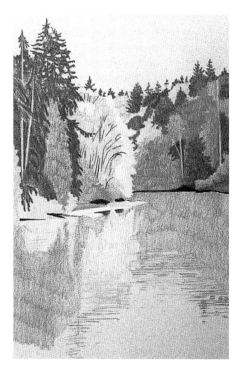

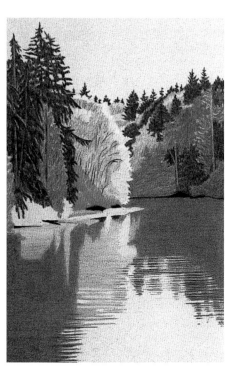

1 Apply the First Washes

Wash in the trees using Dark Green and Marine Green for the darkest trees, and Olive Green, Peacock Green, True Green and Limepeel for the lighter trees. Use Jasmine to wash the very lightest trees. Vary your pressure for these washes and use a loose scribble stroke and a dull point.

Quickly wash the water with Olive Green and Jasmine, using a light touch, a slightly dull point and vertical line stroke, except for the ripples, which are drawn in horizontally using a sharper point.

2 Build Color and Value

Continue to build color and value in the trees using Indigo Blue, Black and Dark Green on the darkest trees and Marine, Olive, Apple and Celadon Greens on the lighter trees. Add a few trunk lines with Dark Umber.

Build up the color very quickly with a medium layer of Olive Green using a vertical line stroke, followed by a layer of Dark Green. Use more pressure on this last layer, as well as a sharp point and a smooth, horizontal stroke. Add Limepeel in the same manner over the previously applied Jasmine layer.

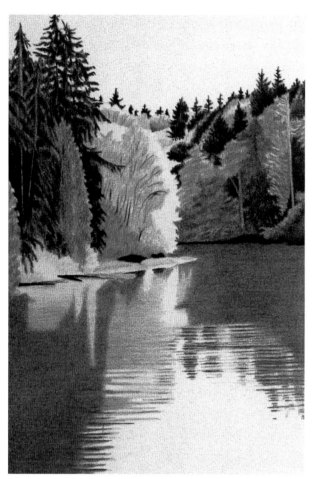

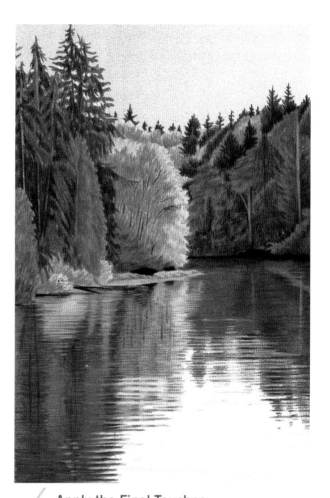

3 Darken the Trees

Continue to darken the trees using Limepeel, Olive and Marine Greens with a little True Green on the bank. Tone down the lighter trees and the greenery around the bank with Celadon and Marine Green, and then pull all of the greenery together by applying Marine Green over the midtone trees.

4 Apply the Final Touches

Use French Grey to draw in the tree trunks on the right side and a few horizontal ripple lines. With Dark Green, Peacock Green and Sepia, darken the water using sharp points and horizontal strokes. Draw a few horizontal strokes with Spring Green as a reflection for the lighter greenery above the bank. Add vertical strokes with Light Umber to serve as reflections of the tree trunks. Use Marine Green and a tiny bit of Dark Green horizontally across this lighter section of water. Also use a little True Green in the bank and the greenery near the bank. On the left side of the water, use French Grey to add the tree trunk lines, then darken it with horizontal strokes of Sepia. Go into the yellowish section from either side with Apple, Marine and Sepia, using a sharp point. Use White to add a few light reflections in the water, then use Cloud Blue in sparse streaks in the section previously left white.

ESTABLISH VALUE WITH COLORED PENCILS

Janie Gildow

As with any medium, value can make or break a colored pencil drawing. Here are two ways of defining your values.

Grisaille (pronounced **greese-Eye**)

Color added to value can sometimes be confusing, so many artists like to establish all of the values before applying any color. It's a much easier method to use if you have trouble interpreting color value.

Reverse Grisaille

When you work on a dark ground rather than a light one, you have to think in reverse as you develop the values. Instead of using pencils that are darker than the ground, you must use pencils that are lighter. Since the colored pencil is semitransparent, most colors will look darker when applied to a dark ground. Where you want color to be dark, just apply it directly to the dark ground, but in order to make color light and bright, you'll need to first apply either white or one of the light opaque colors under it.

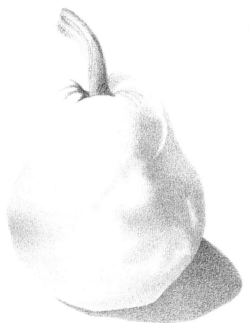

GRISAILLE
This tonal drawing, created with French Greys, is now ready for color. The values are all established and the layers that make up the local color mix should be applied right over the grays.

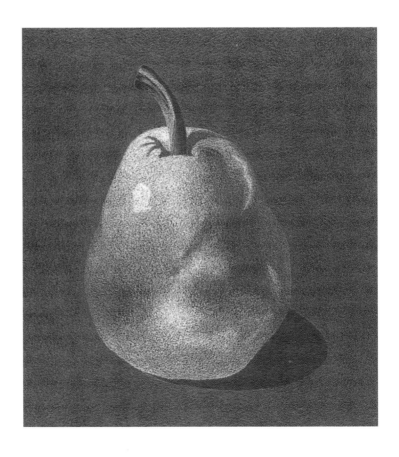

REVERSE GRISAILLE
The lighter values are established with white or opaque light colors. Any colors applied over the light foundation will be lighter than colors applied directly to the black ground. Coloring in the background around the cast shadow allows the shadow to keep its darkness.

DEFINE VOLUME WITH PASTELS

Achieving complete and even coverage with colored pencil is a timely process. A layer of pastel color on the paper's surface saves time and quickly provides a tinted base for the pencil. You can use graded color to develop volume with the pastel, or you can just apply the pastel as a flat color and use the pencil to develop changes in contour.

The pastel is applied first and sprayed with fixative so the consequent layers of pencil will adhere to it. The waxiness of the pencil discourages the pastel from sticking to it, so it works best when it is applied last.

Keep in mind that the pastel color, not the color of the paper, will be what shows through the applied pencil as little dots of color.

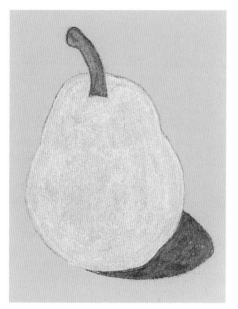

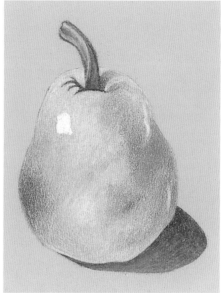

DEFINING COLOR AND VALUE WITH PENCILS
Lay down a flat color (just one value) with the pastel, then develop color and value changes with the pencil. The flat color affects the overlying semitransparent pencil and shows through the pencil as tiny dots. This method is considerably slower than the method shown below.

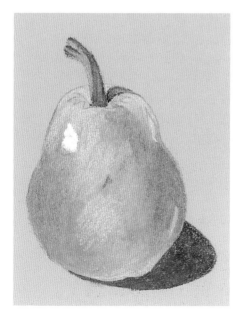

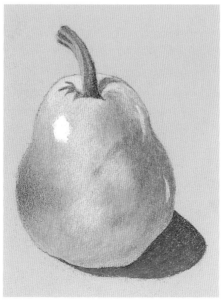

ESTABLISHING VOLUME WITH PASTELS
Develop volume (by changes in color and value) with the pastel. Then add the colored pencil. You won't need to spend as much time applying the pencil since the color/value changes are already made.

Combining Mediums to Create Excitement

If you want to emphasize and take advantage of the pastel application techniques, you can work more loosely, then enhance the work with colored pencil, keeping the exciting strokes of the pastel evident in the finished piece.

MATERIALS LIST

Surface
140-lb. (300gsm) hot-pressed watercolor paper

Pastel Pencils
Dark grass green, dark pine green, gold ochre, indigo, light cloud blue, light warm gray, medium grass green, medium warm brown, olive green, pine green, terra cotta, yellow green

Prismacolor Colored Pencils
Rosy Beige, Apple Green, Blue Violet Lake, Celadon Green, Chartreuse, Cloud Blue, Dark Brown, Goldenrod, Indigo Blue, Limepeel, Marine Green, Periwinkle, Sienna Brown, Slate Grey

Other
Art knife, battery-powered eraser, graphite pencil, matte workable fixative

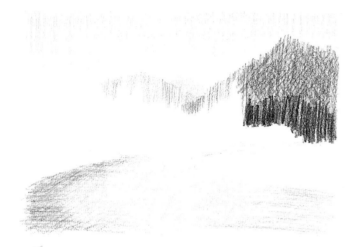

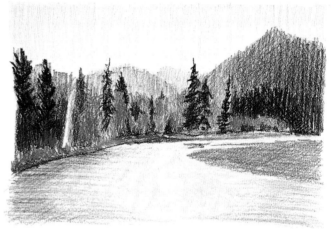

1 Lay in the Groundwork With Pastel Pencil

Use a pencil to loosely map out the basic shapes of your landscape. Apply light cloud blue to the sky using vertical strokes. Apply light warm gray lightly in the same manner over the sky to indicate an overcast day.

Use dark pine green in vertical strokes for the distant mountain. Use dark pine green and indigo crosshatching in the near mountain.

Use dark pine green and indigo vertical strokes to make a dark mass of trees by the near mountain. Apply light cloud blue and light warm gray in horizontal strokes to the dark edge of the river. Toward the middle of the river, apply light cloud blue with short strokes going in many different directions (scumble) to indicate the surface and current in the water, then move into vertical strokes on the right side. Spray all with workable fixative.

2 Continue to Build Color With Pastel Pencil

Warm the shore with earth tones. Refine the water line with terra cotta. Apply medium warm brown and gold ochre to the left shoreline.

Add indigo to the darker parts of the water and along the waterline to indicate the reflections of the trees in the water. Darken the mountains with indigo and pine green and the trees with indigo. On the lighter trees, use a combination of medium grass green, yellow green and olive green. The yellow in these three greens will coax the trees to jump forward and appear closer. Spray all with workable fixative.

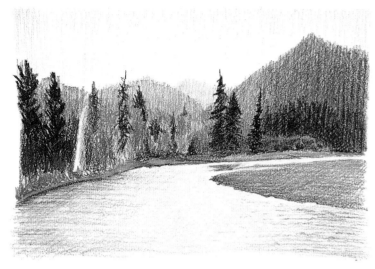

3 Refine the Right Side With Colored Pencil

Apply Rosy Beige to the shoreline, the right shore and the mountains. This repetition of color will help unify the color in your composition.

Add Blue Violet Lake to the mountains by crosshatching. These separate strokes of color will begin to soften the color of the pastel, contributing to the impression of depth and distance, or aerial perspective.

Smooth the center of the river with Cloud Blue. Use Slate Grey and Periwinkle to define the water surface, indicating the current and the reflected trees.

Even out the color of the sky with Blue Violet Lake and Cloud Blue.

Apply Marine Green to the water at the left shoreline reflections and to the leafy trees to warm them. Use Dark Brown to edge and define the right shoreline. Color the farthest part of the right shore with Cloud Blue and, to warm and bring the nearest part forward, apply Goldenrod.

Use Indigo Blue in the pines to darken and define them. Apple Green, Celadon Green and Limepeel in the lighter trees will build rich color.

4 Complete the Left Side With Colored Pencil

Fill in and define the trees with Chartreuse, Celadon Green and Apple Green. Use these light colors to brighten and warm the leaves. Darken the pines even more with a heavier application of Indigo Blue. Use an art knife to scratch out the white trunks and branches of trees here and there.

Complete the shoreline with Sienna Brown and Goldenrod. Use the battery-powered eraser to lighten the shoreline and indicate the riverbank.

Complete the water with Slate Grey and Periwinkle. Both colors add blue to boost the color of the water.

Separate strokes of both pastel and colored pencil should be evident in your finished landscape. The color palette indicates a gray and overcast day.

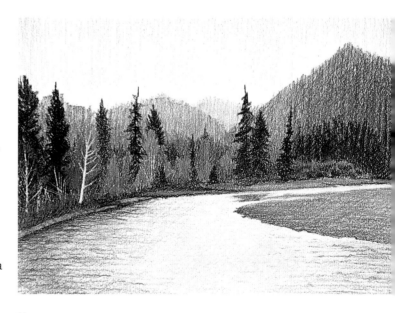

Homonym
Janie Gildow, CPSA
6" x 8" (15cm x 20cm) Colored pencil and pastel on
140-lb. (300gsm) hot-pressed watercolor paper

Underpainting With Watercolor

MATERIALS LIST

Surface
140-lb. (300gsm) hot-pressed watercolor paper

Brush
no. 4 round

Grumbacher Artists' Watercolor
Burnt Sienna, Cadmium Yellow Medium, Cobalt Blue, Cobalt Violet, Emerald Green

Prismacolor Colored Pencils
Apple Green, Burnt Ochre, Cloud Blue, Dark Green, Grass Green, Indigo Blue, Limepeel, Peacock Green, Tuscan Red, Yellow Chartreuse

Other
Battery-powered eraser, graphite pencil

It's easy to make an apple that glows with color when you first underpaint with watercolor and then add colored pencil. The wash of watercolor fills in and tints the fibers of the paper. It also changes the tooth, giving hot-pressed papers and boards just that little bit of texture necessary for accepting multiple layers of colored pencil.

Not only does applying a layer of watercolor first speed up the coloring process by giving you the opportunity to color an entire area quickly, it lends richness to the colored pencil and adds a new depth of color not possible with either medium alone.

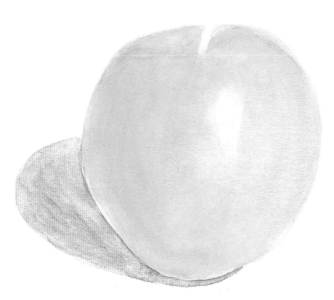

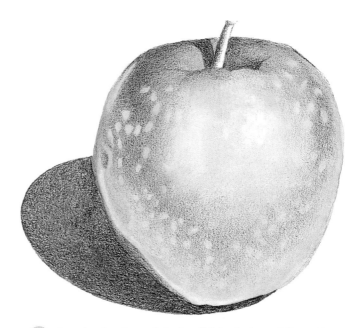

1 Lay a Watercolor Base
Draw your apple using light pencil lines. Tint the apple with an Emerald Green, Cadmium Yellow Medium and Burnt Sienna mix, keeping the color more concentrated on the shadowed side and thinning the mix with water as you approach the highlight. Let dry.

Mix Cobalt Blue, Cobalt Violet and Burnt Sienna for the shadow. Add a tiny amount of Cadmium Yellow Medium to warm and mellow this cool blue. Let dry.

Your application of watercolor doesn't have to be smooth and even. When you layer the pencil over the area of dried watercolor, your brushstrokes won't show.

2 Begin the Local Color With Colored Pencil
Use Indigo Blue to contour the apple and create the illusion of depth. Let the local color show through the freckles. Reduce pencil pressure toward the highlight, on the left edge of the apple, and on the bottom near the shadow. Then apply Dark Green over the Indigo Blue in exactly the same manner.

Use Indigo Blue to establish the shadow on the left side of the stem. The cast shadow is darkest immediately under the apple and gradually lightens upward. Use Indigo Blue to even the application of watercolor and fill in color. Reduce pressure toward the upper part of the shadow to lighten it just a little.

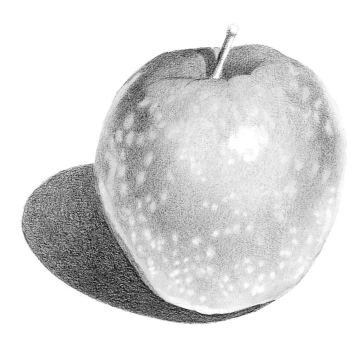

3 Deepen the Values

Apply Peacock Green over the mix of Indigo Blue and Dark Green on the apple and extend the coverage closer to the white highlight and out toward the edge of the apple. Lightly apply Grass Green around the white highlight. Reduce pressure even more toward the darker areas to gradually blend it into the already applied color. Soften the contrast of the freckles on the top half of the apple by coloring lightly over them with Apple Green. Use the battery-powered eraser to lift color and lighten the spots on the bottom half of the apple.

Apply a mix of Grass Green and Apple Green immediately under the apple as reflected color in the shadow. Add a light layer of Tuscan Red to warm the center portion of the shadow and emphasize the bottom edge of the apple.

4 Make the Color Pop

In the lightest areas of the apple (around the highlight and at the bottom), layer a combination of Limepeel and Yellow Chartreuse. Use Tuscan Red to punch up the color at the top edge of the apple, the shadow cast by the stem, and the valley around the stem. This dark red adds a soft complement to the green.

Apply Burnt Ochre over the entire stem to complete its local color.

Use Cloud Blue on the lightest part of the shadow and reduce pressure toward the darker area to gradually blend and smooth the mix.

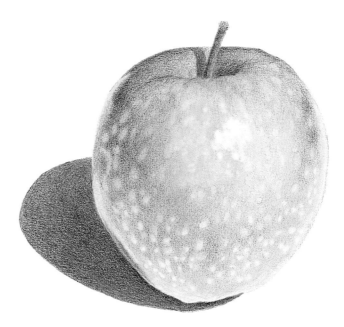

Good Enough to Eat
Janie Gildow, CPSA
3" x 4" (8cm x 10cm) Colored pencil and watercolor
on 140-lb. (300gsm) hot-pressed watercolor paper

USING INK WITH COLORED PENCILS

Janie Gildow

Unlike watercolor, ink cannot be manipulated once it dries on the paper surface. Ink stays put. So you must be careful where you put it. As ink dries, it develops an edge of more concentrated color. Ink can be thinned with water to produce a range of values, but when mixed with greater and greater amounts of water, it becomes less and less waterproof. At the same time, it becomes more vulnerable to changes affected by its combination with other mediums, and to lifting methods such as erasers, adhesive tape, mounting putty, art knives, etc.

Due to the dyes from which they are made, many of the colored inks, especially the bright ones, are notorious for being fugitive, which means they fade over time. When I use ink, I mix colors that are dull and use them for their gray value. Once the ink is dry I apply colored pencil over it to enhance and enrich the color.

Pens

Pens are marking instruments that contain a reservoir of a liquid medium. Usually, pressing the nib (point/tip) to your drawing surface releases the liquid and allows it to move from the reservoir to the nib and then flow onto your paper. The shape of the nib influences the distinctive mark made by the liquid.

INDIA (BLACK) INK
India ink contains carbon particles suspended in a fluid binder composed of water and shellac or latex. India ink is opaque and very black when used full strength.

CHARACTERISTICS OF INK

- Most colored inks are not particularly lightfast.
- India ink washes make excellent values for grisaille.
- Once ink dries, it's permanent.

COLORED INKS
Colored inks derive their color from dyes. Ink is permanent which just means that it's waterproof. It doesn't mean it is lightfast. The colors are often fugitive and can fade in time.

TECHNICAL PEN

Outlining is easy if you use a technical pen, but you'll need to clean the pen often to keep it working well. Technical pens look like fountain pens, but the nib is a hollow tube with a thin wire inside of it. The wire moves back and forth, allowing the ink to flow out of the tube. The wire is extremely vulnerable and you should take great care of it when cleaning the pen. A bent wire will clog the tube and prevent the flow of ink. These pens contain reservoirs that are filled easily. You can use colored inks and India inks in technical pens. The easiest brand of technical pen to use and care for is the Koh-I-Noor Rapidograph. Nibs are available in sizes that range from no. 6x0/.13, which creates an extremely thin line, to no. 7/2.00, which creates a very thick line.

SPEEDBALL PEN

A Speedball pen has interchangeable nibs to create lines of different widths and shapes. These inexpensive pens are usually used for calligraphy, but they can also be used for drawing and sketching. The nib is split, allowing the flow of ink from the reservoir. As you press the pen point to the drawing surface, the two sections spread apart and the ink flows. Ink is held in the reservoir by capillary attraction. However, the reservoir is small and you must fill it often. A dropper stopper, or a container with a tiny spout, works very well for this purpose.

 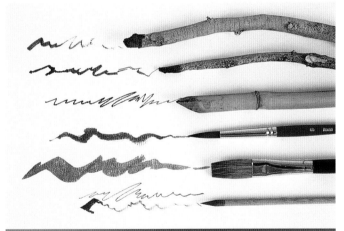

CROW QUILL PEN

The crow quill pen also has a split nib that allows ink to flow from its tip. The curve of the quill acts as the only reservoir, so you must dip the entire nib repeatedly into your ink container to keep it full and keep the ink flowing. Originally these pens were made from actual bird quill feathers. Now the interchangeable nibs are made of extremely flexible metal and the handles are generally made of plastic.

BRUSHES AND OTHER APPLICATORS

Depending upon the effect you want to produce, any brush works with inks. Just be sure to clean it well and don't allow ink to dry in it. Dried ink is just as permanent in brushes as it is on paper. Foam brushes, cotton swabs, tree branches and meat sticks all dispense ink to greater or lesser degrees and exhibit their own unique marks.

Establishing an Ink Foundation for Color

MATERIALS LIST

Surface
140-lb. (300gsm) hot-pressed watercolor paper

Brush
no. 12 round

Ink
Blue, brown, gray, orange, purple, red

Prismacolor Colored Pencils
Black Cherry, Black Grape, Cloud Blue, Dark Purple, Deco Orange, Goldenrod, Henna, Limepeel, Olive Green, Rosy Beige, Slate Grey, Terra Cotta, Tuscan Red

Other
Colorless Blender pencil

Ink works well for color and value under colored pencil, but due to the dyes from which ink is made, many of the colors, especially the bright ones, are notorious for being fugitive. So when you use ink, mix colors that are dull and use them for their gray value. Apply colored pencil over the ink to enhance and enrich the color.

In this exercise, you'll establish an ink color value foundation and then complete the red grapes by punching up the color with layers of colored pencil.

Lightest wash (1)

Lightest wash (2), middle value (1)

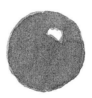
Lightest wash (2), middle value (2)

Lightest wash (2), middle value (2), dark value (1)

Lightest wash (2), middle value (2), dark value (3)

1 Develop Grape Values by Layering

After sketching your grapes and cast shadow, start painting the grapes. Mix red, brown, purple and gray inks to make a raisin color. Divide the color into thirds. Add enough water to one part to create a middle value. To another, add more water to create a lighter value. To the last, add a small amount of water for a darker and more concentrated color.

Use combinations of these washes to create changes in value in the grapes. Apply the lightest wash to all the grapes. Leave the lightest grapes with only one light-value wash. Begin to darken the rest by applying another wash of the lightest value over the first. Use your middle value to darken others further. To some, apply only one middle-value wash, and to others, apply two. To complete the grapes, use the darkest wash. On some grapes, apply one dark-value wash right over all the others. On the darkest grapes continue to apply two, or even three, washes of the darkest value.

The numbers in parentheses above indicate the number of washes applied to each grape shown.

2 Lay in the Cast Shadows With Ink

Once the grapes have dried, start painting the cast shadows. Mix orange and blue ink, adding the orange a little at a time. The color of the shadow should still be blue, but a muted and soft blue. Add enough water to create a medium value wash. Using a brush and clean water only, wet the area of the shadow. Apply the blue wash to the damp paper. It will fill the area and will be easy to apply smoothly.

Some of the grape color reflects into the shadow, so while the shadow is still wet, add a little of the middle-value grape color to it along the edge where it meets the grapes. Let the color softly spread into the blue.

3 Complete the Grapes With Colored Pencil

Each grape is different from the others, so complete the grapes by varying the color combinations slightly. Establish the contours with the darkest values and enrich the local color with the midtones. Create the bloom on the grapes with Cloud Blue.

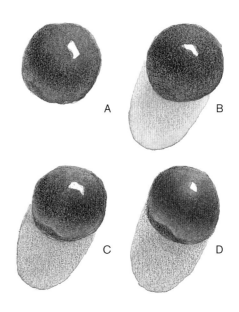

A. Start by developing the contours of the grapes with the darkest values: Black Grape, Black Cherry, Tuscan Red and Dark Purple.

B. Enrich the local color mix with the midtones: Henna, Terra Cotta, Tuscan Red and Slate Grey.

C. Add the light and the bloom with the lightest value: Cloud Blue.

D. Using circular strokes, go over the entire grape with the Colorless Blender to smooth and even the color. Work from light to dark, but check the pencil point often and, if it picks up color, wipe it on a tissue so you don't transfer color where you don't want it.

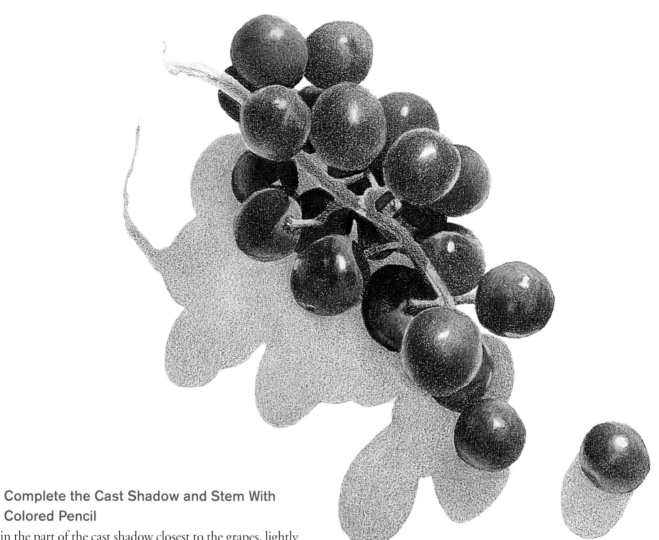

4 Complete the Cast Shadow and Stem With Colored Pencil

First, in the part of the cast shadow closest to the grapes, lightly layer a combination of Rosy Beige and Deco Orange to suggest the reflected color of the grapes. Reduce pressure toward the outside edge of the shadow to gradually lighten the application.

Second, layer Slate Grey evenly over the entire shadow.

Third, go back into the shadow nearest the grapes and boost the reflected color with a light layer of Terra Cotta.

Apply a light layer of Limepeel to the entire stem to establish a base for the other colors. Then go back over the stem and apply Olive Green to create value changes as shown. Apply Goldenrod and Terra Cotta to warm the greens. Then add Black Grape to suggest the shadows and value changes. Apply it right over the other colors to darken them as needed. It will mellow the other colors and allow them to look more natural.

Prelude
Janie Gildow, CPSA
7" x 7" (18cm x 18cm) Colored pencil and ink
on hot-pressed 140lb. (300gsm) watercolor paper

CONCLUSION

In general, drawings fall into one of three catergories: a sketch to be completed at a later time or place, done to rough out a scene or record immediate impressions; a study of one element of a composition that will make its way into a larger work; or a finished piece of art, intended to stand on its own. Whatever your reason for drawing, whatever you are looking to accomplish, the tools in this book will help you on your way. Keep putting pencil to paper, and you'll be creating realistic, inspiring drawings that capture the world and people around you in no time.

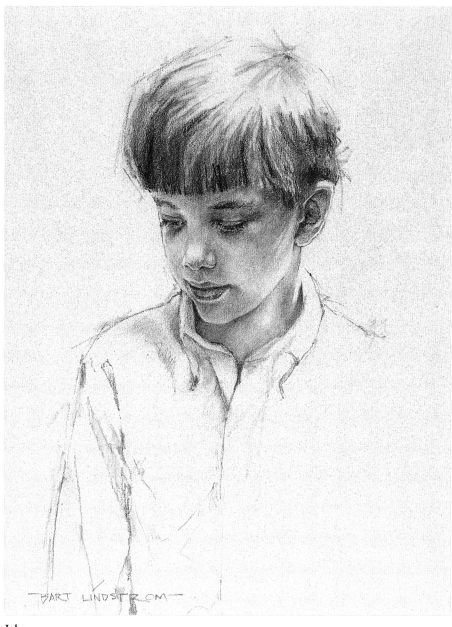

John
Charcoal
17" x 14" (43cm x 36cm)

INDEX

A
Accent marks, 46–47
Accuracy, checking for, 53
Anatomical reference, 45
Atmospheric perspective, 25

B
Background, adjusting values to, 34
Backlight, 36–38, 67
Baseline, 50, 52
Bickford, John, 20–21, 70–71
Blending, 12, 14
Blocking, 14–15
Borders, 58–59
Burnishing, 110

C
Center of interest, 28
Charcoal, 12
Chiaroscuro, 25
Chiseled edge, 14–15
Colored pencils, 104
 color combinations, 111
 color mixing with, 108
 combining ink and, 120–121
 combining pastels and, 116–117
 defining color and value with, 115
 establishing value with, 114
 even application of, 106
 paper for, 105
 pressure and value changes with, 107
 reflections with, 112
 sharpening, 107
Colorless Blender, 110
Complex objects, 17
Composition
 framing, 58
 See also Space, division of
Contrast, softening, 14
Cross-contour drawing, 90
Crosshatching, 13, 14–15, 20
 open, 109
Curves
 shadows around, 43
 See also Rounded objects

D
Depth
 creating, 60–61
 sense of, 25, 28, 29
Distance
 figures receding into, 61

roads winding into, 69
 viewing art from, 53
Drawing, rapid, 26–27
Drawing media, 10–13
Drawing techniques, 14–15

E
Edges
 chiseled, 14–15
 contour lines, 25
 types of, 48–49
Erasers
 battery-powered, 119
 types of, 22–23
 using, 21–23
 See also Kneaded eraser
Eye level, 58, 59

F
Fabric folds, 17
Faces
 in profile, 74
 shadows on, 41
 sketching, 30
Figures, 88–93
 clothing on, 100–101
 constructing, 91
 hands, 98
 receding, 61
 shapes and gestures, 90
 skeletal sources for, 92–93
Flat surfaces, 17
Focal point, 28
Foreshortening, 25
Forests, 66–67
Framing, 58–59
Front light, 36
Front-quarter light, 36–37

G
Gesture drawing, 90
Gildow, Janie, 16–17, 104–111, 114, 115, 116–117, 118–119, 120–121, 122–124
Golden mean, 54
Graphite pencils, 10
 water soluble, 11
Graphite sticks, 10
Gray scale, 35
Gridlines, 44–45
Grisaille, 114

H
Hatching, 13, 20
 with charcoal, 12
 with eraser, 23
Hidden perspective, 61
Highlight
 creating, with kneaded eraser, 15
 white, 119
 See also Lifting out
Horizon, eliminating, 59
Horizon line, 28

I
Impressed line, 110
Ink
 characteristics of, 120
 colored, 13, 120
 combining colored pencils with, 120–121
 as foundation for color, 122–123
 India, 13, 120
Inverting art, 53

J
Johnson, Cathy, 10–13
Juxtaposing color, 109

K
Kneaded eraser, 15, 22, 34
Kohn, Andre, 98
Krieger, Butch, 24, 30, 34–35, 40–41, 44–45, 46–47, 74–76, 77–79, 80–82, 83–85, 86–87, 88–91, 100–101
Kullberg, Ann, 112–113

L
Landscapes, 39, 57–71
Layering
 colored pencils, 108
 ink, 122
Leveille, Paul, 14–15
Lifting out, 15, 119
Light
 dark vs., 14
 direction of, 59
 importance of, 16–17
 in landscapes, 39
 reflected, 38, 112–113
 shadows and, 42–43
 single source of bright, 40
 types of, 36–38
Lindstrom, Bart, 94–96

126

Linear perspective, 25
Lines
 adding body to, 46
 charcoal, 12
 contour, 25
 impressed, 110
 See also Strokes

M
Maltzman, Stanley, 65–67
McClish, Jerry, 28–29, 36–38, 42–43, 54–55, 58–59, 60–61, 62–64, 68
Mirro, Rocco J., 92
Mistakes, 24

N
Negative shapes, 25
Negative values, 44–45
Newfield, Martha, 22–23
Newton, Barbara Benedetti, 16–17, 104–105

O
Objects
 complex, 17
 rounded, 17
 shadow side of, 42

P
Paper
 toning, 22
 types of, for colored pencil, 105
 used with stumps, 21
Paper stump, 14, 18, 20
Parks, Carrie Stuart, 18–19, 50–53
Pastels
 combining colored pencils and, 116–117
 defining volume with, 115
Pen and ink, 13, 120–121
Pencils
 colored. See also Colored pencils
 types of, 10–11
Pens, 13, 120–121
Perspective
 hidden, 61
 principles of, 25
 realism and, 62–64
Photographs, baselines in, 50–51
Portraits, 72–87
 ears, 77–79
 of elderly, 86–87
 eyes, 74–76

hair, 79, 80–82
 self-portrait, 83–85
 showing personalities in, 94–96
Power points, 46–47
Proportions
 checking, 50
 in figures, 91

R
Rabatman, 55
Rankin, David, 39
Realism
 creating with light and shadow, 16
 defining edges for, 48–49
 perspective and, 62–64
 using roads to add, 68–69
Reflections
 in water, 112
 See also Light, reflected
Reverse grisaille, 114
Reversing art, 53
Roads, 68–69
Rocks, 70–71
Ruler, 53

S
Shading techniques, 18–19
Shading tools, 18–19
Shadows
 angles of, 29, 43
 cast, 16–17, 41, 42, 123–124
 form, 16
 hatching or crosshatching, 20
 light and, 42–43
 subtleties of, 40–41
Sidelight, 36–37
Size, relative, 60–61
Sketchbook, spiral-bound, 27
Sketching
 complete sketch, 28–29
 from memory, 30–31
 hands, 99
 tips for daily, 24–27
Skin, creating smooth, 19
Smudging, 18
 creating tones by, 20–21
 with eraser, 23
Space
 creating, 60–61
 division of, 54–55, 59. *See also* Composition
Squinting, 94

Stippling, 13
Stomp, 20. *See also* Paper stump
Strokes
 circular, 123
 colored pencil, 106
 range of, 29
 See also Lines
Stump. See Paper stump
Subject
 framing, 58–59
 measuring, 50

T
Techniques
 drawing, 14–15
 shading, 18
 See also entries for specific techniques
Texture, 29
Three dimensions, 29, 41, 52
Three-quarter backlight, 36–37
Thumbnail sketch, 24, 33
Tilton, Bill, 32–33, 48–49
Toned drawing, 21
Tones
 creating by smudging, 20–21
 smooth, with charcoal, 12
Toning the paper, 22
Top light, 38
Tortillion, 14, 18, 20
Tracing paper, 19
Trees, 65–67

U
Underpainting, 118–119

V
Value, 29
 adjusting, 34–35
 establishing with colored pencils, 114
Value changes, 18
Value scale, 32–33, 35
Vanishing point, 59, 62–63, 68–69
Volume
 creating, 49
 defining with pastels, 115

W
Watercolor, underpainting with, 118–119
Watercolor sketch, 26
White areas, preserving, 19

LEARN TO DRAW LIKE THE PROS WITH THESE OTHER FINE NORTH LIGHT BOOKS!

PAINTING LIGHT WITH COLORED PENCIL
by Cecile Baird
ISBN-13: 978-1-58180-530-7, ISBN-10: 1-58180-530-6,
HARDCOVER, 128 PAGES, 32883

Capturing light is difficult for any artist, but perhaps even more so when you're working in colored pencils. Now there's a guide that can help! Following this helpful guide and more than twenty lessons covering a variety of subjects from flowers to water will help you on your way to rendering realistic light.

DRAW NOW
by Ruth Glenn Little
ISBN-13: 978-1-58180-595-6, ISBN-10: 1-58180-595-0,
PAPERBACK, 96 PAGES, 33108

If you are a beginning artist learning to master the basics of this important artistic skill, let *Draw Now* be your guide. These thirty easy exercises will teach you progressive skills and start you down your artistic path.

SECRETS TO REALISTIC DRAWING
by Carrie Stuart Parks & Rick Parks
ISBN-13: 978-1-58180-649-6, ISBN-10: 1-58180-649-3,
PAPERBACK, 128 PAGES, 33238

If you're an artist armed only with a pencil, this book is for you! *Secrets to Realistic Drawing* will have you creating lifelike drawings in no time by teaching you the principles of drawing in a clear and concise manner. The techniques, strategies and step-by-step demonstrations will help you quickly realize your artistic dreams.

THE DRAWING BIBLE
by Craig Nelson
ISBN-13: 978-1-58180-620-5, ISBN-10: 1-58180-620-5,
HARDCOVER WITH WIRE-O BINDING,
304 PAGES, 33191

The Drawing Bible is the definitive resource you need in order to master this important medium—it will teach you both how to draw and how to use your drawing materials to the best advantage. Learn how to realistically capture a variety of popular subjects and conquer the most crucial drawing principles today!

These books and other fine North Light titles are available at your local fine art retailer or bookstore or from online suppliers.